ICONS

Male Nudes

Cover . Umschlag . Couverture:
Wilhelm von Gloeden, c. 1900

pp. 30/31:
Gaudenzio Marconi, Homme nu dans la position
de la création d'Adam de Michel-Ange, 1870
Cliché Bibliothèque Nationale de France, Paris
pp. 42/43:
Wilhelm von Gloeden, c. 1900
pp. 60/61:
George Platt Lynes, Monroe Wheeler, 1935
Anatole Pohorilenko Collection, New York
pp. 86/87:
Herbert List, Nach dem Bad, 1955
© Herbert List Nachlass – Max Scheler, Hamburg
pp. 110/111:
Anonymous, 1960s
pp. 134/135:
Jeff Palmer, The Grey Couple, 1991

Acknowledgements

David Leddick would very much like to thank
his publisher, the genial and gifted **Benedikt
Taschen** and his editor, the smart and charming
Nina Schmidt.
Also with great appreciation, he would like
to express his thanks to **the photographers,
collectors, galleries and museums** that made
this book possible.

© 2001 TASCHEN GmbH
Hohenzollernring 53, D–50672 Köln
www.taschen.com

Text by David Leddick, Paris
Editorial coordination by Nina Schmidt, Cologne
Cover design by Angelika Taschen, Cologne
German translation by Thomas Stegers, Berlin
French translation by Philippe Safavi, Paris

Printed in Italy
ISBN 3–8228–5526–X

Dedication

**For my great and good friend
Kevin Voelcker**

Male Nudes

TASCHEN

KÖLN LONDON MADRID NEW YORK PARIS TOKYO

Contents . Inhalt . Sommaire

The Liberation of the Male Nude Image in the 20th Century

There are many men and women taking photographs of the male body, publishing them in an assortment of magazines and selling them to collectors. Nowadays the sight of a male nude in a photograph is no longer exceptional. But this was not always the case.

At the turn of the 19th century, the male nude was almost entirely absent from photography, with the exception of Sandow, a blond bodybuilder from Königsberg in what was then Prussia. A former artist's model, he became known as the World's Strongest Man. Florenz Ziegfeld took him in hand after his first appearance in the United States and soon he became known as "The world's most perfect man." The popular 'cartes de visite', similar to today's postcards, featured Sandow in nothing but a fig leaf. But he seemed to be the only one who could get away with it. Male nudity was beyond the pale and was allowed only rarely in painting or in the occasional vaudeville show. In the framework of art, male nudity regained respectability. The naked female body, in contrast, had never been lost to view since the days of antiquity.

In ancient Greece the nude male body was considered the ideal subject for sculpture. The tunics and togas in which men dressed in any case left much

male flesh exposed. However, conducting sports competitions completely nude was a conscious decision on the part of the Greeks. Previously the young men had worn some kind of cover-up, but it was decided that they should run, wrestle, throw javelins and the discus naked. This was perhaps because the form of homosexuality the Greeks condoned – an interest of older men in younger men – led the older men to want to see the younger men performing in a perfect and unadorned state, as much like statuary as possible.

Quite obviously the male body was considered a sex object at that time – more so than the female body, which was less often sculpted than the male and frequently veiled in draperies.

The tradition of male nude sculpture for use in monuments and the beautification of wealthy men's villas continued into the Roman era, but with the rise of Christianity the male nude disappeared. In fact, under the influence of the Eastern church, which forbade images, all depictions of humans ceased. The church did nonetheless allow iconic representations of the saints and important figures, but these were two-dimensional and usually executed in chaste mosaic.

What a relief the Renaissance must have been for lovers of the human form. The long years of waiting were well rewarded. Michelangelo led the way with his *David*, and many tomb and decorative sculptures. The male nude forms on the ceiling of the Sistine Chapel were in the same style as his sculpture: imposing, noble figures that hearkened back to the past. Classical sculptures were recovered from centuries of subterranean seclusion to reveal ancient ideals of beauty in the form of the male body. Contemporary sculptors occasionally buried their work, hoping to have it 'uncovered' as an antiquity!

The male nude, as sculpted and cast in bronze by Donatello, Cellini, Michelangelo, and many others, became an accepted form of art in the Renaissance and thereafter. The Renaissance, introduced into France through the efforts of Francis the First in the seventeenth century, heralded the return of the male nude – and the female too, of course. The willowy, slim-hipped, long-legged females featured in the sculpture of the time are close to the models of today. Buxomness was to come later. The male nude remained the stalwart, well-muscled warrior type that was predominant in Italian art.

The art training of this time required students to draw their subjects nude, before painting them fully dressed; this led to a truer understanding of the human body and how it worked. Leonardo da Vinci had examined cadavers, and art and medicine advanced together in their exploration of the body. Even the Sun King Louis XIV was drawn nude before being painted with all his robes and scepter. Is it possible that the very well-built body in the drawing was the king's own? It seems unlikely that he would have had the patience to pose, but then again he was considered handsome in his youth.

Paintings of the gods and assorted mythological scenes continued to include the male nude through the 16th and 17th centuries in France, but less in northern countries. Dürer was a handsome man and portrayed himself in the nude. He frequently painted male and female nudes, and, though he did not draw on the classic tradition, there was a certain realism about his male figures. The northern climate would have discouraged any display of nudity: clothes were essential there. In France and Italy, however, warmer weather gave a certain freedom to the body, and seeing it partially unclad was no novelty.

In the early 19th century, with the rise of Napoleon, art styles changed to some degree, and painting and sculpture were often used to serve the greater glory of the Emperor. Napoleon wanted to secure his shaky throne by welding it to solid traditions of the past. Painters like David obliged and naked men abounded in paintings like *The Oath of the Horatii*, designed to ennoble war and warriors. The sculptor Antonio Canova was enormously successful in producing classical forms in pure white marble. His large and naked Napoleon was not much favored by the emperor, however, and finally found a home in Wellington's sumptuous town house in London, as a kind of war trophy after his defeat of Napoleon at Waterloo.

In the 1830s, after Napoleon's fall, a more commercially oriented government headed by Louis-Philippe, the 'Citizen King', swept images of the nude male abruptly from the scene. Contemporary man, buttoned-up in a black suit and wearing a top hat, appeared incongruous beside his classical counterpart.

The first photographers, however, quickly developed a lucrative business copying models' poses and selling them to artists. Procuring live models was

always expensive for struggling painters, and photographs of models in a series of classic poses were of great utility. This is how the photographic male nude came into being. Images of models squatting, bending, lifting, or struggling with another male nude were copied and used as source material by a flood of artists, mainly in Paris.

In the United States in the latter part of the 19th century, the Philadelphian painter Thomas Eakins used photography to create poses and scenes for use in his own paintings. These photographs were themselves works of art. There also seems to have been a voyeuristic side to his work. He obviously derived enjoyment from enticing good-looking young men to shed their garments and pose for a photograph – highly unusual behaviour in prudish Victorian society.

One of the first steps away from using art as an excuse for looking at the male body was taken by Eadweard Muybridge. Fascinated by human and animal bodies in motion, he devised a technique using a sequence of cameras to photograph movement. His male and female nudes ran, jumped, danced, shot-putted, and displayed how the body actually performs when moving. These photographs took a very long time to be published in the straitlaced American society of the 1870s and 1880s but science eventually prevailed, and photographic images of the male nude became available for the first time to the general public.

Among the first art photographs of the male nude were those taken by Baron Wilhelm von Gloeden in Taormina, Sicily. The expatriate Baron was short of funds and photographed local boys, clad only in wreaths and sandals, and sometimes even less. These pictures supposedly recaptured the naked lifestyle of ancient Greece and were sold to tourists. The Baron's cousin, Guglielmo Plüschow, did similar work and, by the end of the century, male nudes not even pretending to be ancient Greek replicas were being shot by several photographers in Rome. At the same time in Germany, Theodor Hey was photographing less classical male nudes, mainly in sunlit outdoor settings.

Just before World War I Diaghilev's Ballet Russe, on tour from Russia, had an enormous impact on music, painting, fashion and behavior in general. Its stars, among them Nijinsky and Pavlova, were frankly sexual on stage and their repertoire of ballets created an atmosphere of powerful emotion and dissolute

movement. And what was more, you could clearly see the dancers' lithe and slender bodies.

The war brought an end to much Victorian hypocrisy and prudery, perhaps in part because clothing became less formal. Men in uniform and women engaged in war work couldn't afford to be constricted or spend time dressing elaborately. For women in particular, dress became much simpler, with corsets and full-length skirts being abandoned. War always brings a relaxed moral code with it and this livelier, more overtly sexy world welcomed new advances in art photography, including many nudes.

Art photographers like Fred Holland Day had photographed misty, wistful youths lounging around on large rocks and in sylvan pools before the war. But after the war Imogen Cunningham photographed her handsome husband Roi clambering about Mount Rainier in the buff in a more realistic way. And the unfettered 1920s brought both male and female movie stars prepared to show unlimited amounts of flesh.

Rudolf Valentino and Ramón Navarro were two stars with an ambiguous sexuality whose bodies were their business. The motion picture industry saw that men as sex objects were good box office, and so proceeded to present the public with more. This was fertile ground, previously held by Sandow and his body beautiful alone. It represented a major step away from the formal Victorian male image, complete with beard and black three-piece suit.

Vaudeville regularly presented dancers like Ted Shawn of the Denishawn company and circulated photographs for fans everywhere. These images usually showed the performers in their stage attire, or lack of it.

The freeing of the body had been anticipated before World War I by 'naturalists' and nudists, who vacationed in the nude. Men, furthermore, had a growing interest in improving their physique, and once they developed it, the tendency was to want to show it off. This became the subject matter for magazines which began to appear in the post-war period, increasing the visibility of the male nude image.

While nature and nudist magazines had their serious readers, they also presented an opportunity for a more general public to see naked men and women.

Despite their innocent nature, however, these magazines were kept on top shelves or under the counter and the brave buyer had to ask for them.

The physique magazines began as equally innocent vehicles for the exchange of tips on weight-training and diet. But the accompanying pictures of the hale and hearty weightlifters pleased a homosexual readership that never went near a gymnasium. The publishers were quick to comprehend this, and these magazines soon began to portray their body-building stars in more sensually exciting ways.

Actors' and dancers' publicity stills, and photographs of nudists and body-builders, formed the sum total of material available to the average nudity-lover before World War II.

By the 1930s, some photographers like George Platt Lynes in the United States, Angus McBean in England, and Raymond Voinquel in France were photographing the male nude, but this was largely for the pleasure of their friends. A male nude would occasionally appear in a photography exhibition, but this was rare. Most men were still reluctant to see themselves as nature made them.

World War II loosened morals and dress codes even further, and after the war physique magazines appeared in a brand-new format. This was 'beefcake' for beefcake's sake, as exhibited by Bruce of Los Angeles, Lon of New York and a number of others. Now there was a real plethora of images for those who wanted them.

Yet the male nude image was still under fire. Throughout the 1950s and into the 1960s, photographers and particularly Bob Mizer's *Physique Pictorial* magazine came under constant attack, but by 1968, Lynn Womack, the publisher of *Grecian Guild Pictorial*, finally managed to convince the Supreme Court that nudity was not obscene. This represented a big step forward for the male nude and one that was quickly seized upon by photographers and magazines.

By the late Sixties, attitudes toward 'getting naked' were becoming relaxed, but despite nude streakers featuring regularly in the newspapers, it took a while for art photography to catch up. While nude images spread rapidly in what was still the under-the-counter press, they had a tougher time being accepted into the art world.

Ten years after the Supreme Court decision, the first show devoted to male nudes at the Marcuse Pfeifer Gallery in New York met with a poor reception from male critics. They still saw the male nude as the province of homosexuals or women who wanted to view men in a reduced way, stripped of power. Only René Ricard caught what was bothering the critics. He wrote, "Don't men's genitals have a certain ... decorative look, like an accessory thrown in to be amusing?" The penis was the problem. Men did not want their penises to be seen as amusing. And to avoid that response it was better to cover up.

Unfortunately for the critics, the tide was against them. Robert Mapplethorpe was already on the New York scene at the time of the exhibition and was soon to be recognized as a major force in the art world. His flowers and pretty people and large penises were a heady combination for the financially flush public of the 1980s. It was the beginning of the disco era; people were sexually active and AIDS had not yet hit. The male nude had won respectability. This was art and the public was buying it. Following Mapplethorpe into the arena were the commercial photographers Bruce Weber, Herb Ritts, Francesco Scavullo, Greg Gorman and many others. Soon the male nude was selling underwear, fragrance, and women's wear.

Books, calendars and postcards proliferated, along with gay porn films and their evanescent 'stars', who became overnight celebrities. Jeff Stryker appeared in *Interview Magazine*. He had no problem about telling his female interviewer which part of his anatomy set him apart from other porn stars.

By the 1990s, frontal male nudity had become ubiquitous. Film stars like Bruce Willis and Tim Robbins openly permitted us a glimpse of their genitalia. Movies about the making of porn movies had arrived on the scene.

And now with the male nude out of the closet, codes of dress are becoming even more relaxed. Business wear is becoming sporty. Even very serious companies allow casual wear on Fridays. Many firms in warmer climates such as Los Angeles or Miami make no formal requirements at all. In Miami Beach even the policeman wear shorts and ride bicycles. And they have to have nice legs, too.

The patriarchal Victorian figure in his buttoned-up collar is gone. His present-day counterpart is passé and only to be found lurking in the most

rarefied heights of executive offices. Younger men are working out at the gym. Their wage-earning wives and girlfriends demand it.

It took two wars and a lot of determined men and women photographers to get men out of their duds and back to the Classical and Renaissance view of what a man is: beautiful, on a par with women. Now men and women share many of the same kinds of jobs and responsibilities. It is no longer the man's job to bring home the bacon and the woman's job to fry it and look beautiful at the same time. Beauty is now as much a man's responsibility as a woman's.

Strangely enough, we're finding that those qualities homosexual men have always admired in other men are exactly what women like too. It's just that nobody ever asked them before. Dependent upon men, they kept their mouths shut. Now they can admire a strong thigh, a broad back, or a rippling abdomen. What has been demanded of women for centuries – "be beautiful" – is now being demanded of men too. Males may be surrendering their Big Daddy image by going naked, but they are also entering a more user-friendly mode.

Just as it is unlikely that women will return to the kitchen and give up their freedom, there is little chance that the male nude will cover up again any time soon. It took a century for the male body to fight its way clear of clothing. It feels good. And what we learned in the 20th century is, if it feels good ... do it.

Die Befreiung des Männeraktes im 20. Jahrhundert

Viele Fotografen, Männer wie Frauen, machen Aufnahmen von nackten Männern und es gibt ein breites Spektrum von Magazinen, die ihre Fotos veröffentlichen und zumeist an interessierte Sammler verkaufen. Der Anblick eines Männeraktes lässt heute keinen mehr erschauern.

Gegen Ende des 19. Jahrhunderts hingegen war der nackte Mann fast gänzlich aus der Öffentlichkeit verbannt. Eine der seltenen Ausnahmen war Eugene Sandow, ein blonder Hüne aus Königsberg im damaligen Preußen. Sandow, ursprünglich ein Aktmodell, hatte sich durch das, was wir heute Bodybuilding nennen und was damals schlicht Gewichtheben hieß, zum „stärksten Mann der Welt" gestählt und machte auch international Furore. Er ging in die Vereinigten Staaten und wurde in Florenz Ziegfelds legendäre Schauspieltruppe aufgenommen. Die beliebten „cartes de visite", vergleichbar den heutigen Starpostkarten, zeigten Sandow mit nichts als einem Feigenblatt bekleidet. Davon werden wohl nicht nur weibliche Fans entzückt gewesen sein.

Wenn man will, kann man fern hinter Sandow die Statuen des antiken Griechenlands entdecken, die Verkörperungen des ewigen Kanons klassischer Schönheit. Doch diese Ahnenreihe weist Unterbrechungen auf. Während der

weibliche Akt seit der Antike niemals dem Blick entschwunden ist, fehlt dem männlichen Pendant diese Kontinuität – zumindest einem männlichen Akt, der Virilität, animalische Leidenschaft und Schönheit ausdrückte.

In der Antike war der nackte männliche Körper das häufigste Motiv in der Bildhauerei, was unter anderem sicher daran lag, dass z.B. im antiken Griechenland der körperliche Umgang unter Männern zwangloser war. So war es damals eine bewusste Entscheidung der Griechen, sportliche Wettkämpfe völlig nackt durchzuführen. Anfangs bedeckten die jungen Männer noch ihre Scham, aber dann beschloss man, die olympischen Disziplinen völlig nackt auszutragen. Der Grund hierfür mag in der Duldung einer besonderen Form der Homosexualität gelegen haben – der Hinwendung älterer Männer zu jüngeren Männern. Bei den Älteren hatte dies den Wunsch aufkommen lassen, die Jüngeren so, wie die Natur sie geschaffen hatte, antreten zu lassen, damit sie so statuengleich wie möglich wirkten.

Die Tradition, Statuen nackter Männer in öffentlichen Gebäuden, auf Plätzen oder in Privatvillen wohlhabender Bürger aufzustellen, setzte sich im antiken Rom fort. Mit dem Aufkommen des Christentums verschwanden die Darstellungen männlicher Akte. Der Einfluss der Ostkirche, die Bildnisse jeglicher Art verbot, reichte sogar so weit, dass auf Darstellungen alles Menschlichen überhaupt verzichtet wurde.

Was dem christlichen Mittelalter fremd bleiben musste, gelang erst der Renaissance: die Wiederentdeckung antiker Motive und antiker Themen. Michelangelos *David*, seine Grabdenkmäler und zahlreiche weitere Statuen lassen den stattlichen, edlen Mann der Antike wieder auferstehen und mit ihm den Kanon klassischer Schönheit. In der Sixtinischen Kapelle malte Michelangelo den nackten männlichen Körper im Stil seiner Statuen.

Als die Renaissance während der Herrschaft von König Franz I. in Frankreich Einzug hielt, kam mit ihr auch die Aktdarstellung. Die gertenschlanken, schmalhüftigen und langbeinigen Frauen, die sich in der Bildhauerei der damaligen Zeit finden, kommen dem weiblichen Idealtypus unserer Tage sehr nahe. Bei den männlichen Akten herrschte auch weiterhin der muskelbepackte kriegerische Typus vor, wie man ihn aus Italien kannte.

Von den angehenden Künstlern wurde im Zuge ihrer Ausbildung verlangt, dass sie ihre Modelle erst nackt zeichneten, bevor sie bekleidet gemalt wurden – eine gute Gelegenheit, die Kenntnisse über den menschlichen Körper zu vertiefen. Leonardo da Vinci untersuchte Leichen, um sein Wissen über die Anatomie zu vergrößern. Kunst und Medizin gingen in der weiteren Erforschung des Körpers gemeinsame Wege. Sogar Ludwig XIV. wurde erst nackt gezeichnet, bevor er in vollem Ornat porträtiert wurde. Allerdings ist die Frage erlaubt, ob für den außerordentlich gut gebauten Körper auf dem Gemälde wirklich Ludwig XIV. Modell gestanden hat, da es unwahrscheinlich ist, dass der König hierzu die Geduld aufbrachte; andererseits galt er in seiner Jugend als eine Schönheit.

So wird uns über die Jahrhunderte nur selten ein Blick auf den männlichen Akt gewährt. Und er blieb zumeist auf Götterbildnisse sowie die Darstellung mythologischer und allegorischer Szenen beschränkt. In nördlicheren Gefilden waren Aktdarstellungen weniger verbreitet. Dürer allerdings, ein gutaussehender Mann, zeichnete sich nicht nur selbst nackt, sondern malte auch Männer und Frauen unbekleidet. Dabei ließ er sich weniger von klassischen Traditionen leiten, seine Männerakte scheinen eher dem alltäglichen Leben abgemalt zu sein. Das Klima im Norden verhinderte die Zurschaustellung von Nacktheit, Bekleidung war unerlässlich. Hingegen sorgte in Frankreich und Italien ein wärmeres Klima für eine gewisse Freizügigkeit.

Die Herrschaft Napoleons Anfang des 19. Jahrhunderts brachte eine Veränderung des künstlerischen Schaffens mit sich; der Kaiser vereinnahmte die Kunst häufig zu Propagandazwecken. Napoleon wollte seine unsichere Monarchie unbedingt in der Vergangenheit verankern und durch die Berufung auf die Tradition legitimieren und Maler wie Jacques Louis David kamen diesem Ansinnen entgegen. In dem Gemälde *Der Schwur der Horatier* wimmelt es förmlich von nackten Männern, einzig zu dem Zweck, den Krieg zu verherrlichen.

Und als das Bürgertum die alte Herrschaftsschicht ablöste, wurde dieser Freizügigkeit schnell ein Ende bereitet. Der Bürger, das heißt der um Macht und wirtschaftlichen Erfolg ringende Mann, hätte es nur als Verlust seiner Würde verstehen können, wenn man ihn in seiner Körperlichkeit bloßgestellt hätte.

Erst mit dem Aufkommen der Fotografie im 19. Jahrhundert gewann der männliche Akt wieder an Bedeutung. Die Anfänge waren durchaus prosaischer Natur. Die ersten Nacktfotos von Männern sollten weniger gut betuchten Künstlern die teuren Aktmodelle ersetzen. Ihnen kamen Aktfotos in klassischen Posen sehr gelegen und so hielt der nackte Mann Einzug in die Fotografie. In der Hocke, ein Gewicht stemmend, im Ringkampf mit einem anderen Mann – solche Szenen wurden in großer Zahl fotografiert und dienten zahllosen Künstlern als Vorlage.

So machte sich in der zweiten Hälfte des 19. Jahrhunderts etwa auch der amerikanische Maler Thomas Eakins aus Philadelphia die Fotografie zunutze, um Posen und Szenen zu kreieren, die er dann in seinen Gemälden umsetzte. Eakins Arbeiten waren sicherlich nicht frei von einem voyeuristischen Motiv. Aus den Bildern spricht auch eine deutliche Begeisterung aller Beteiligten. In der steifen Atmosphäre seiner Epoche muss das etwas Ungewöhnliches gewesen sein.

Einer der ersten, dem nicht die Kunst den Vorwand lieferte, einen Blick auf den nackten männlichen Körper zu werfen, war Eadweard Muybridge. Muybridges Interesse galt dem Körper in Bewegung und er entwickelte eine Technik, mit Hilfe mehrerer Kameras Bewegungsabläufe im Bild festzuhalten. Seine nackten Männer und Frauen sind beim Laufen, Springen, Tanzen oder Kugelstoßen zu sehen und veranschaulichen die tatsächlichen Bewegungsabläufe. Doch selbst diese wissenschaftlichen Studien konnten in der sittenstrengen amerikanischen Gesellschaft der 1870er und 1880er Jahre nur gegen hartnäckigen Widerstand veröffentlicht werden.

Die ersten Fotos nackter Männer, die echte künstlerische Aktfotos sind, nahm Baron Wilhelm von Gloeden im sizilianischen Taormina auf. Der in Italien lebende Baron fotografierte die Jungen seiner Wahlheimat im Adamskostüm. Gloeden wollte in seinen Bildern das freie, ungezwungene Leben im antiken Griechenland nachempfinden. Seine Kunden waren durchreisende Touristen. Zugleich betrieb er einen florierenden Versandhandel. Guglielmo Plüschow, ein Vetter des Barons, arbeitete in Neapel auf dieselbe Art und Weise. Zusätzlich entstanden in Rom gegen Ende des Jahrhunderts Aktaufnahmen von Männern,

ohne den Rückbezug auf ein fernes Arkadien. In Deutschland fotografierte zur selben Zeit Theodor Hey nackte Männer, zumeist im Freien, in der Sonne. Hey setzte seine Arbeit bis zum Ausbruch des Ersten Weltkrieges fort.

Ein neues Körperbewusstsein vermittelte auch das Diaghilev-Ballett aus Russland, das Europa im Sturm eroberte. Nijinsky und Pavlova, die Stars des Balletts, stellten sich auf der Bühne ungeniert zur Schau. In allen Stücken des Repertoires herrschte eine Atmosphäre starker Emotionalität: Die Bewegungen waren raumgreifend und die geschmeidigen, schlanken Körper der Tänzer zeichneten sich deutlich unter der Kleidung ab.

Vor dem Ersten Weltkrieg hatten Fotografen wie Fred Holland Day ihre wehmütig blickenden Modelle zumeist noch vor großen Felsen und an Waldseen abgelichtet. Imogen Cunningham dagegen konnte ihren hübschen Ehemann Roi nach dem Krieg bereits im Adamskostüm beim Klettern im Gebirge fotografieren.

Auch die Filmstars der 1920er Jahre, Männer wie Frauen, hatten nichts dagegen, viel nacktes Fleisch sehen zu lassen. Ihre Fotografien wurden ebenso gerne gekauft wie die prominenter Tänzer des Vaudevilles, etwa eines Ted Shawn, der in äußerst knappen Bühnenkostümen aufzutreten pflegte.

Die Befreiung des Körpers war bereits vor dem Ersten Weltkrieg von Naturfreunden und Nudisten propagiert worden. Unter den Männern wuchs das Interesse an körperlicher Ertüchtigung. Dem neuen Körpergefühl verdankten die so genannten *Physique*-Magazine ihr Entstehen. Sicher hatten diese Magazine auch ernsthaft interessierte Leser, aber sie boten ebenso allen anderen die Gelegenheit, Männer und Frauen nackt zu betrachten, wenn sie den Mut aufbrachten, nach den trotz ihres harmlosen Charakters unter Ladentischen versteckten Heften zu fragen. Auch die reinen Bodybuilder-Zeitschriften fingen recht harmlos als Informationsbörsen mit Tipps zur richtigen Ernährung etc. an. Die dazugehörigen Abbildungen gesunder und kräftiger Gewichtheber gefielen auch einer homosexuellen Leserschaft, die ein Sportstudio wohl niemals betreten hätte. Die Verleger stellten sich schnell auf diese Leserschicht ein und porträtierten ihre Bodybuildingstars zunehmend in aufreizenden Posen.

Die Nudisten- und Sportmagazine lieferten neben den Standfotos von Schauspielern und Tänzern das einzige Material, auf das der Liebhaber des Män-

neraktes Zugriff hatte. In „ernsthaften" Fotoausstellungen blieb der männliche Akt weiterhin die Ausnahme.

Nach dem Zweiten Weltkrieg erschienen die Bodybuilder-Magazine in selbstbewussterer Aufmachung. Endlich wurde „Männerfleisch" ohne Vorwand gezeigt. Bruce of Los Angeles, Lon of New York und viele andere zeigten den nackten Mann unverblümt als Lustobjekt.

Dennoch blieb das männliche Aktfoto eine Provokation. In den 50er und 60er Jahren sahen sich viele Fotografen, vor allem Bob Mizers Zeitschrift *Physique Pictorial*, ständigen Attacken ausgesetzt. Erst 1968 erstritt Lynn Womack, Herausgeberin der *Grecian Guild Pictorials* vor dem Obersten Gerichtshof die Entscheidung, dass Nacktheit nicht obszön ist.

In der etablierten Kunstszene fand der männliche Akt aber auch jetzt noch keine Anerkennung. Als zehn Jahre nach der Entscheidung des Obersten Gerichtshofes die Marcuse Pfeifer Gallery in New York erstmals eine Ausstellung ausschließlich mit Männerakten präsentierte, stieß sie in der Kritik auf Ablehnung. Männerakte galten immer noch als Domäne von Homosexuellen oder als boshafter Versuch weiblicher Künstlerinnen, Männer ihrer Würde zu berauben. Doch der Zeitgeist sollte sich rasant wandeln. Robert Mapplethorpe hatte zur Zeit der Ausstellung bereits die New Yorker Szene betreten und avancierte bald zum Star. In den hedonistischen 80ern waren seine Bilder von Blumen, attraktiven Menschen und großen Genitalien eine fulminante und erfolgreiche Mischung. Es war die Disco-Ära: Sex war zügellos, AIDS als Gefahr noch nicht erkannt, und der nackte Mann war nicht mehr verpönt. Der Männerakt war Kunst und er war kommerziell erfolgreich. Zu Mapplethorpe gesellten sich Werbefotografen wie Bruce Weber, Herb Ritts, Francesco Scavullo, Greg Gorman und viele andere. Fotos nackter Männer halfen, Unterwäsche, Parfüms und Damenmode zu verkaufen.

Das Geschäft mit Büchern, Kalendern und Postkarten mit männlichen Akten florierte und selbst die „Stars" schwuler Pornofilme avancierten zu wenn auch flüchtigen Berühmtheiten. Im *Interview Magazine* erschien ein Interview mit Jeff Stryker, in dem er der Interviewerin ohne Scheu verraten durfte, wie viel ihn von anderen Pornodarstellern unterschied.

In den 90er Jahren war der nackte Mann allgegenwärtig. Filmstars wie Bruce Willis oder Tim Robbins gestatteten uns freimütig flüchtige Blicke auf ihre Genitalien. In Miami Beach tragen heute sogar Polizisten Shorts und fahren Rad und kräftige Oberschenkel haben sie auch noch.

Viele Jahre und das Engagement zahlreicher Fotografinnen und Fotografen waren nötig, um den Mann von seinen Kleidern zu befreien, zu den Vorbildern der Antike und Renaissance zurückzukehren und den nackten Mann in seiner kreatürlichen Schönheit wiederzuentdecken. So unwahrscheinlich es ist, dass die moderne Frau sich wieder in ihre traditionelle Rolle zurückdrängen lässt, so unwahrscheinlich ist es, dass der nackte Mann sich wieder verhüllt. Es hat lange gedauert, das Kostüm abzulegen. Aber das fühlt sich gut an. Und wenn es sich gut anfühlt: Tu es einfach.

La libération du nu masculin au XXᵉ siècle

Il existe désormais beaucoup d'hommes et de femmes qui photographient le corps masculin pour tout un assortiment de revues ou des collectionneurs. La vue d'une photo d'homme nu ne fait plus frémir personne.

Mais cela ne fut pas toujours le cas. A la fin du XIXᵉ siècle, il était quasiment impossible de voir un homme nu, à l'exception de Sandow, un culturiste blond de Königsberg (alors en Prusse orientale). Ancien modèle d'atelier, Sandow fut surnommé « l'homme le plus fort du monde ». Lorsqu'il émigra aux Etats-Unis, Florenz Ziegfeld le prit en main et le promut rapidement « l'homme le plus parfait du monde ». Les cartes postales d'alors, très populaires, le présentaient vêtu d'une simple feuille de vigne. Toutefois, il était apparemment le seul à pouvoir se le permettre car la nudité masculine se cachait soigneusement, ne faisant que quelques rares apparitions fugitives dans les tableaux ou sur les scènes de vaudeville. Dans les deux cas, elle se devait de faire référence à la tradition artistique, ce qui lui conférait un certain degré de respectabilité.

Dans la Grèce antique, le corps nu de l'homme était le sujet de prédilection des sculpteurs. Cela s'explique certainement par le fait que les hommes se promenaient partout en petite tunique ou en toge, et que le corps n'était pas

tabou. Néanmoins, que les athlètes participent aux compétitions sportives entièrement nus n'était pas tout à fait innocent de la part des Grecs. Les premiers temps, les jeunes sportifs portaient bien un petit quelque chose, jusqu'à ce qu'il soit décidé officiellement que, dorénavant, ils courraient, lutteraient, lanceraient le javelot et le disque dans le plus simple appareil. Cela était dû sans doute au fait que la forme d'homosexualité admise par les Grecs, à savoir l'attrait des hommes mûrs pour les hommes plus jeunes, incitait les amateurs de compétitions sportives à vouloir admirer leurs protégés à l'œuvre dans toute leur perfection et simplicité.

De toute évidence, le corps de l'homme était alors considéré comme un objet de désir ; plus que celui de la femme, qui était moins fréquemment sculpté et le plus souvent drapé dans des étoffes.

La tradition qui consistait à embellir les monuments publics et les villas de riches patriciens avec des sculptures d'hommes nus perdura dans la Rome antique, puis disparut avec l'avènement du christianisme. De fait, sous l'influence de l'Eglise de rite oriental, qui interdisait les images, toute représentation humaine disparut. Lorsque l'Eglise chrétienne finit par s'assouplir, elle autorisa les icônes de saints et de personnages importants, mais sous la forme de mosaïques.

Quel soulagement pour les amateurs de beauté charnelle lorsque survint la Renaissance ! Michel-Ange ouvrit la voie avec son *David* et de nombreuses autres sculptures destinées à orner les tombeaux et les palais. Ses fresques de la chapelle Sixtine lui permirent d'appliquer le même style dans sa sculpture, créant des hommes nus imposants, nobles et inspirés de l'antique. On se mit à creuser la terre pour déterrer les statues grecques et romaines, considérées comme le summum de la beauté masculine.

Le nu masculin, sculpté et coulé dans le bronze par Michel-Ange, Donatello, Cellini et bien d'autres encore, devint un genre artistique reconnu. Lorsque, au début du XVIe siècle, la Renaissance se déplaça en France sous l'égide de François Ier, le nu masculin la suivit. Les femmes idéalisées, longilignes, avec des hanches étroites et de longues jambes, étaient alors proches de nos canons de beauté actuels. Le nu masculin, lui, resta le vaillant guerrier bien bâti qui prédominait en Italie.

La formation artistique de l'époque requérait des étudiants qu'ils dessinent leurs sujets nus avant de les habiller, ce qui favorisa une grande connaissance de l'anatomie et du fonctionnement du corps humain. Léonard de Vinci fit de nombreuses esquisses de cadavres, et l'art et la médecine progressèrent ensemble dans leur étude du nu. Même Louis XIV fut dessiné nu avant d'être revêtu de ses somptueux vêtements de cour et de son sceptre. Est-il possible que le corps si bien fait qui apparaît dans les ébauches soit vraiment le sien ? Il n'avait probablement pas la patience de poser, mais d'un autre côté, on dit qu'il était très beau dans sa jeunesse. Petit, mais beau.

Tout au long des XVIᵉ et XVIIᵉ siècles en France, les dieux de l'Antiquité et les scènes mythologiques continuèrent à offrir de nombreux prétextes pour montrer des hommes nus. En Allemagne, Dürer, qui était fort bel homme, se dessina en tenue d'Adam et réalisa de nombreux nus masculins et féminins. Il ne s'inspirait pas de la tradition classique et ses corps d'hommes étaient plus réalistes. Ceci dit, les nus étaient moins courants dans les pays du Nord, dont les températures n'encourageaient guère la nudité. Rester couvert était une question de survie. En revanche, les climats plus cléments d'Italie et de France donnaient au corps une plus grande liberté. Voir celui-ci partiellement dévêtu n'y était pas une nouveauté.

Au début du XIXᵉ siècle, l'arrivée au pouvoir de Napoléon entraîna un regain d'intérêt pour le classicisme, qui fut souvent exploité par l'empereur comme un outil de propagande. Il tenait à conférer une légitimité à son trône chancelant en l'associant le plus possible aux traditions du passé. Des peintres tels que David relevèrent le défi. Les tableaux de ce dernier, comme *Le Serment des Horaces*, n'étaient pas avares d'hommes nus et visaient à anoblir la guerre et les guerriers. Le sculpteur Antonio Canova parvint à merveille à réinterpréter les traditions classiques dans des formes pures et sensuelles en marbre blanc. Toutefois, son grand nu de Napoléon ne plut pas à l'empereur. Il finit par trouver sa place dans le somptueux hôtel particulier du duc de Wellington à Londres, comme une sorte de trophée de guerre après sa victoire à Waterloo.

Au cours des années 1830, après la chute de Napoléon et l'avènement d'un gouvernement plus orienté vers les affaires, incarné par Louis Philippe, « le roi

commerçant », les images d'hommes nus disparurent brusquement de la scène. Il semblait y avoir une contradiction entre l'image des bourgeois collet monté, engoncés dans des redingotes noires et des chapeaux haut de forme, et le nu masculin traditionnel.

Dès son apparition, la photographie découvrit l'intérêt de faire poser des modèles pour vendre leur image aux artistes. Les modèles vivants coûtaient cher pour les jeunes peintres qui pouvaient ainsi réaliser des études du corps humain à moindre frais. La photo de nu masculin venait de naître. Accroupi, corps fléchi, soulevant des poids, luttant avec un autre homme nu, toutes ces poses étaient reproduites et utilisées comme source d'inspiration par de nombreux artistes, surtout à Paris.

Dans la seconde moitié du siècle, à Philadelphie, le peintre Thomas Eakins photographiait des scènes et des modèles qu'il utilisait ensuite dans ses tableaux. Il alla au-delà de simples études pour créer des photographies qui étaient de l'art à part entière. Son travail avait également un léger parfum de voyeurisme. Il prenait manifestement un certain plaisir à convaincre de beaux jeunes hommes de se déshabiller devant son objectif, ce qui était très inhabituel en cette période de pruderie victorienne.

L'un des premiers à se démarquer de cette tendance, et à se servir du pré-texte de l'art pour admirer des hommes nus, fut Eadweard Muybridge. Fasciné par l'appareil locomoteur humain et animal, il inventa un système photo-graphique qui lui permettait de décomposer le mouvement. Il photographia des hommes et des femmes nus en train de courir, sauter, danser, lancer le poids, afin d'analyser la manière dont s'articulait le corps en action. Ces clichés attendirent longtemps avant d'être publiés dans l'Amérique puritaine des années 1870 et 1880, mais la science eut le dessus et certains privilégiés purent enfin voir des nus masculins.

A Taormina, en Sicile, Wilhelm von Gloeden fut l'un des premiers à réaliser des photographies artistiques de nu masculin. Expatrié et ruiné, le baron pho-tographiait des adolescents vêtus d'une simple couronne de fleurs, et encore ! Ces images, censées évoquer le quotidien de la Grèce antique, étaient vendues aux touristes. Le cousin du baron, Guglielmo Plüschow, concoctait des images

similaires à Naples. Avant la fin du siècle, plusieurs autres photographes romains réalisaient des photos de nu masculin qui ne faisaient plus semblant d'imiter la Grèce antique. A la même époque, en Allemagne, Theodor Hey photographiait des hommes nus dans une veine moins classique et continua de le faire, le plus souvent dans des paysages ensoleillés, jusqu'à la Première Guerre mondiale.

Juste avant la guerre, les ballets russes de Diaghilev débarquèrent de Russie, révolutionnant la musique, la peinture et le comportement général. Leurs vedettes, dont Vaslav Nijinski et Anna Pavlova, avaient une attitude ouvertement érotique sur scène et le répertoire des ballets dégageait une puissante atmosphère d'émotion et d'abandon sensuels. En outre, les costumes des danseurs ne cachaient rien de leur corps souple et élancé.

La guerre asséna un coup rude à l'hypocrisie et la pruderie victoriennes, sans doute en partie parce que les vêtements devinrent moins formels. Les hommes en uniforme et les femmes, qui participaient à l'effort de guerre, ne pouvaient se permettre d'avoir leurs mouvements entravés par des tenues trop étriquées ou sophistiquées. Pour les femmes notamment, la mode devint plus pratique et abandonna les corsets et les jupes longues. Les guerres entraînent toujours un relâchement des mœurs. Une Europe plus assoiffée des plaisirs de la vie et plus libre sur le plan sexuel, accueillit favorablement l'évolution de la photographie… et de ses nus masculins de plus en plus nombreux.

Avant la guerre, des photographes comme Fred Holland Day avaient fixé sur la pellicule dans un flou artistique de jeunes éphèbes mélancoliques et vaporeux couchés sur des rochers ou au bord d'étangs, toujours nus. Mais c'est n'est qu'après la guerre qu'Imogen Cunningham photographia de manière plus réaliste son séduisant mari Roi escaladant nu le Mount Rainier. Dans les années folles, les vedettes de cinéma, hommes et femmes, ne voyaient pas d'objections à être photographiés très légèrement vêtus.

Rudolf Valentino et Ramón Navarro étaient tous deux des vedettes à la sexualité ambiguë dont le corps était le principal outil de travail. L'industrie cinématographique se rendit bientôt compte que les hommes objets remplissaient les salles. Il y avait là un terrain fertile que seul Sandow avait exploré auparavant. Un nouveau pas venait d'être franchi.

Le vaudeville présentait régulièrement des danseurs tels que Ted Shawn, de la compagnie Denishawn, et les photographies destinées à leurs admirateurs les montraient généralement dans leur tenue de scène, à savoir pas grand-chose.

Avant la Première Guerre mondiale, les nudistes et les naturistes, qui passaient leurs vacances nus, avaient anticipé la libération du corps. Les hommes cherchaient de plus en plus à améliorer leur physique. Cela ne nécessitait pas forcément d'être nu mais, après tant d'efforts pour se muscler, ils avaient généralement tendance à vouloir se montrer. Dans la période d'après-guerre, un nouveau genre de revues apparut, s'adressant à ceux qui s'intéressaient au corps humain.

Les magazines de nudisme et de naturisme avaient certes leurs lecteurs assidus, mais ils offraient surtout la possibilité à tous et à toutes de voir des hommes et des femmes nus, et ils ne s'en privèrent pas. En dépit de leur caractère innocent, ils étaient généralement rangés sur le rayon le plus élevé des kiosques à journaux ou sous le comptoir, et le client devait rassembler tout son courage pour les demander.

Les premiers temps, les magazines de culturisme étaient, eux aussi, d'innocents véhicules pour échanger des conseils de régime et de musculation. Mais leurs images de jeunes malabars sains et vigoureux séduisaient également un lectorat d'homosexuels qui ne mettaient jamais les pieds dans un gymnase. Les éditeurs le comprirent rapidement et commencèrent à présenter leurs champions de culturisme sous des formes plus affriolantes.

Avant la Seconde Guerre mondiale, les amateurs de nudité devaient se contenter de clichés d'acteurs, de danseurs, de nudistes et de culturistes. Dans les années 30, des photographes comme George Platt Lynes aux Etats-Unis, Angus McBean en Angleterre et Raymond Voinquel en France photographiaient des hommes nus, mais c'était en grande partie pour le plaisir de leurs amis. Il arrivait qu'un nu masculin parvienne jusque dans une exposition de photographies, mais c'était rare. La réticence des hommes à se voir tels que la nature les avait faits ne se dissipait pas facilement.

La Seconde Guerre mondiale fit encore se relâcher d'un cran les mœurs et les codes vestimentaires. A la fin des années 40, les magazines de culturisme

réapparurent sous un format très différent. Cette fois, on montrait de beaux gosses pour le plaisir de voir de beaux gosses, comme ceux de Bruce of Los Angeles, de Lon of New York et de bien d'autres encore.

Le nu masculin faisait encore scandale. Tout au long des années 50 et 60, les photographes, et notamment la revue de Bob Mizer, *Physique Pictorial*, durent se débattre contre la censure. Il fallut attendre 1968 pour que Lynn Womack, éditeur de *Grecian Guild Pictorial*, parvienne à convaincre la Cour Suprême que la nudité n'était pas obscène. Un grand pas venait d'être franchi, et de nombreux photographes et magazines sautèrent sur l'occasion.

Arrive la fin des années 60. Bien que l'atmosphère générale soit à la liberté des mœurs et que le mot d'ordre soit «nous n'avons rien à cacher», la photographie mit un certain temps à se mettre à la page, en dépit des streakers qui faisaient régulièrement la une des journaux.

Si les photos de nus se multiplièrent rapidement dans une presse toujours vendue sous le comptoir, elles avaient encore plus de mal à se faire accepter dans le monde des galeries d'art.

Dix ans après le jugement de la Cour Suprême, la première exposition consacrée au nu masculin s'ouvrit à la Marcuse Pfeifer Gallery à New York. Elle reçut un accueil glacial de la part des critiques hommes. Pour eux, le nu masculin appartenait au domaine des homosexuels et de féministes qui souhaitaient voir des images d'hommes rabaissés et vulnérables. Seul René Ricard osa déclarer: «...vous ne trouvez pas que les organes génitaux de l'homme ont un certain aspect... décoratif? comme un accessoire qu'on aurait placé là en guise de détail amusant.» Ainsi donc, le problème, c'était le pénis. Les hommes ne voulaient pas que leur pénis prête à rire.

Malheureusement, les critiques n'étaient pas dans l'air du temps. Ou plutôt, heureusement. A l'époque de cette exposition, Robert Mapplethorpe était déjà sur la scène new-yorkaise. Il devait bientôt être reconnu comme une force artistique majeure grâce à sa savante utilisation du sex-appeal et son sens aigu des relations publiques. Ses fleurs, ses portraits de personnalités du beau monde et ses gros plans de sexes masculins offraient une combinaison enivrante pour les nouveaux riches des années 80. Le disco battait son plein, les libidos étaient

galopantes et le sida n'était encore qu'une lointaine rumeur. Le nu masculin devint un art et le public l'apprécia.

Des photographes de publicité emboîtèrent le pas à Mapplethorpe : Bruce Weber, Herb Ritts, Francesco Scavullo, Greg Gorman et bien d'autres encore. Bientôt, des hommes nus vendirent des sous-vêtements, des parfums et de la mode féminine.

Les livres, les calendriers, les cartes postales proliférèrent, tout comme l'industrie du porno gay dont les « stars » évanescentes devinrent des célébrités. Jeff Stryker fut interviewé pour le magazine *Interview*. Il n'eut aucune fausse pudeur à expliquer à la journaliste ce qui le différenciait des autres acteurs du porno.

Dans les années 90, la nudité frontale est partout. Des stars de cinéma comme Bruce Willis ou Tim Robbins n'hésitaient plus à nous laisser entrevoir leurs attributs masculins. Une série de films sur l'industrie du porno se préparent.

Phénomène intéressant, aujourd'hui, à mesure que le nu masculin apparaît au grand jour, le costume étriqué tend à disparaître. Le vêtement de sport devient vêtement de travail. Même des sociétés très guindées autorisent leurs employés à s'habiller plus décontracté au bureau le vendredi. Dans des régions chaudes comme à Los Angeles ou Miami, il n'y a plus aucun code vestimentaire. A Miami Beach, même les policiers sont en short et se déplacent à vélo. Il faut dire qu'ils ont de très jolies cuisses.

L'homme d'affaires victorien collet monté et obsédé par les attributs du pouvoir n'est plus. Il ne subsiste qu'au travers de quelques dinosaures qui hantent les hauteurs étouffantes des bureaux de direction. Les hommes plus jeunes développent leurs pectoraux dans les clubs de gym. Leurs femmes et leurs petites amies l'exigent.

Il aura fallu deux guerres et la détermination de nombreux photographes, hommes et femmes, pour que l'homme baisse enfin son pantalon et renoue avec la vision de l'homme des artistes de l'Antiquité et de la Renaissance : celui-ci doit être beau. Aujourd'hui, hommes et femmes partagent les mêmes emplois et responsabilités et être beau est autant la responsabilité de l'homme que celle de la femme.

Paradoxalement, les qualités que les homosexuels ont toujours admirées chez les hommes sont celles que les femmes apprécient. Personne ne leur avait auparavant demandé leur avis. Dépendantes des hommes, elles se taisaient. A présent, elles sont libres d'admirer une belle cuisse, un dos large, un abdomen en tablette de chocolat. Ce qu'on a exigé d'elles pendant des siècles, « Soit belle », on l'exige désormais aussi des hommes. Ces derniers y ont peut-être perdu leur image de protecteurs mais ils y ont gagné le droit d'être tendres.

Tout comme il y a peu de chances que les femmes retournent un jour dans leur cuisine et abandonnent leurs libertés, il est peu probable que le nu masculin se couvrira à nouveau. Il lui aura fallu un siècle pour se dépêtrer de ses vêtements. Ça fait du bien. Or le XXe siècle nous a appris une chose : quand ça nous fait du bien... alors, il ne faut pas hésiter !

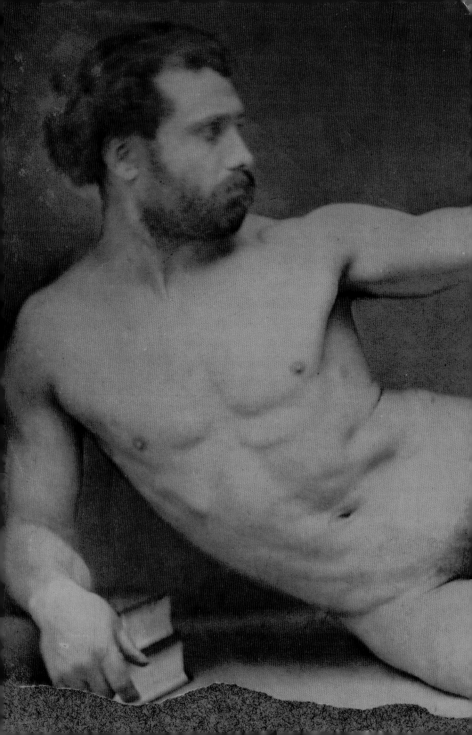

The Nineteenth Century

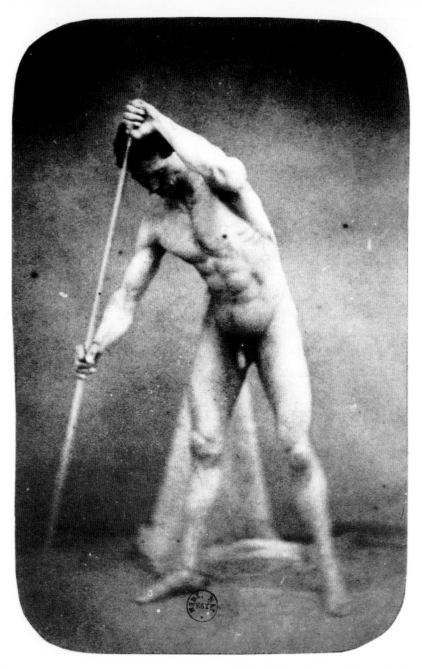

Eugène Durieu, Nu masculin debout, 1854

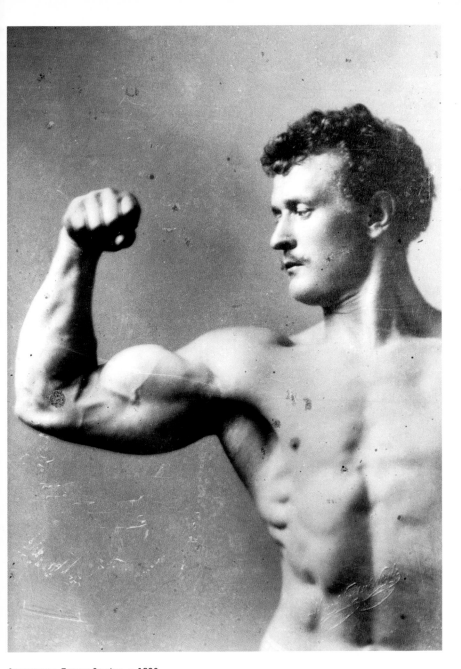

Anonymous, Eugene Sandow, c. 1890

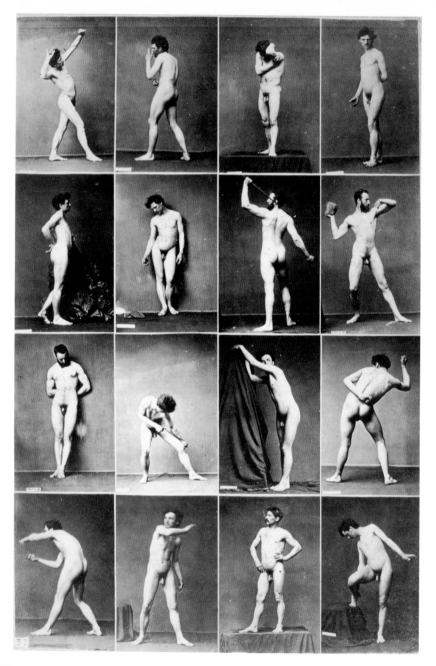

34

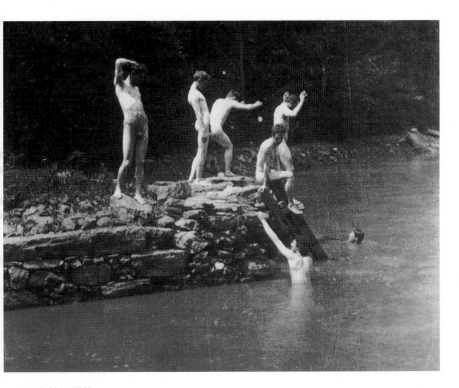

Thomas Eakins, 1883

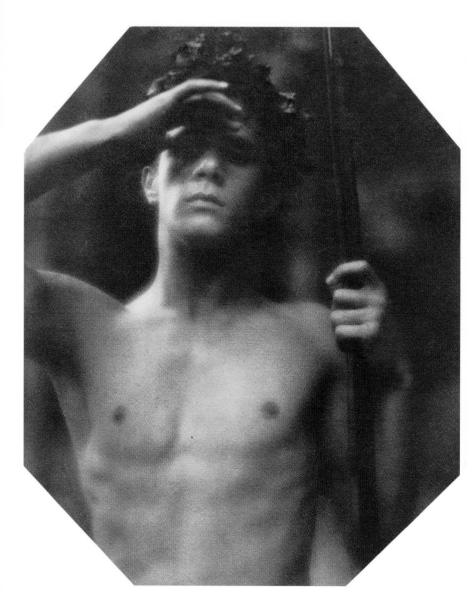

Fred Holland Day, Torso, 1908

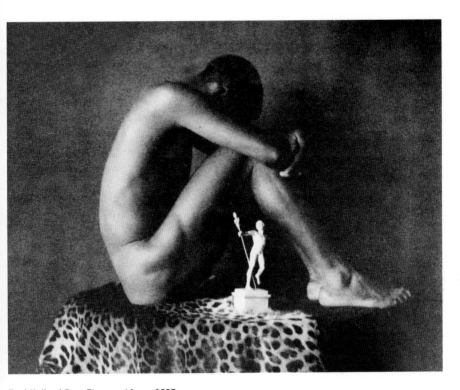

Fred Holland Day, Ebony and Ivory, 1897

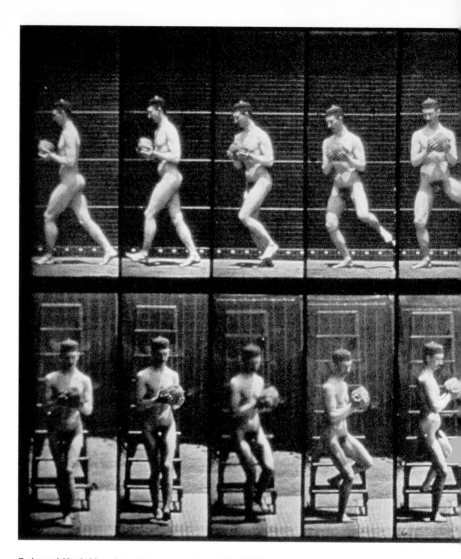

Eadweard Muybridge, Animal Locomotion, Plate 151, 1887

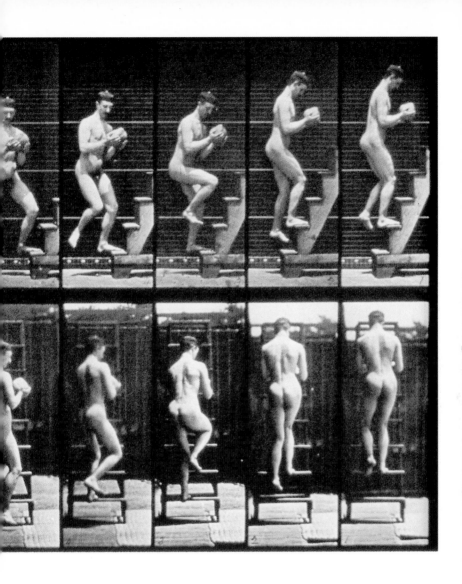

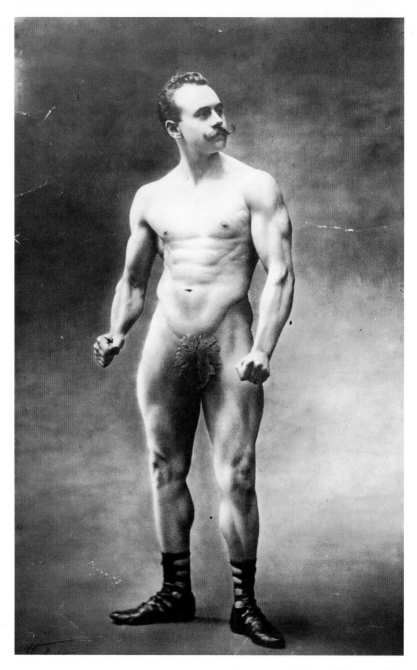

Anonymous, Collection Athlétique, c. 1890

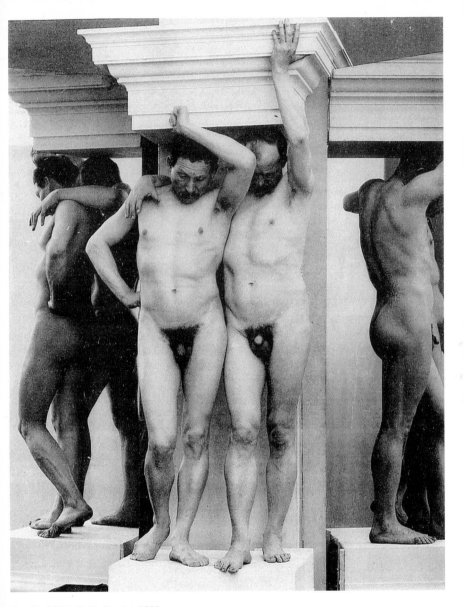

Max Koch/Otto Rieth, Der Act, 1895

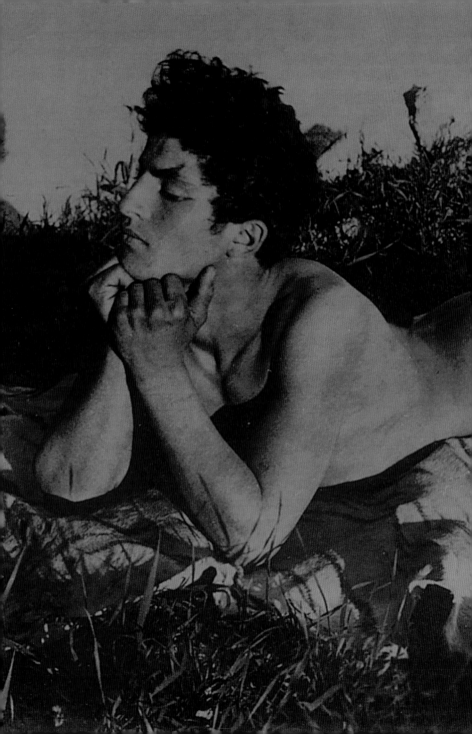

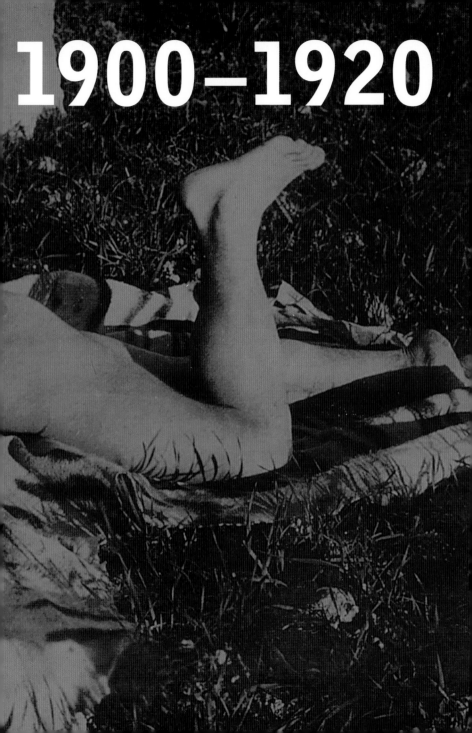

1900–1920

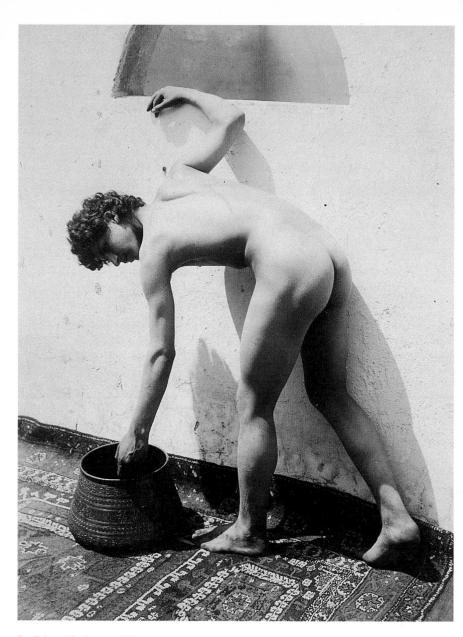

Guglielmo Plüschow, c. 1900

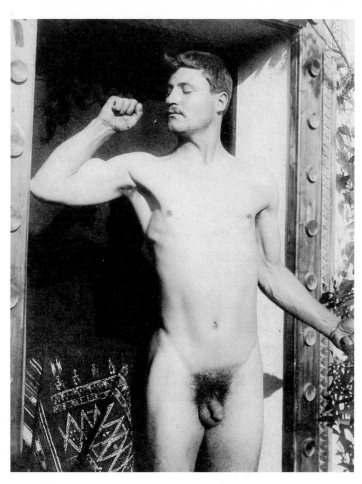

Guglielmo Plüschow, c. 1900

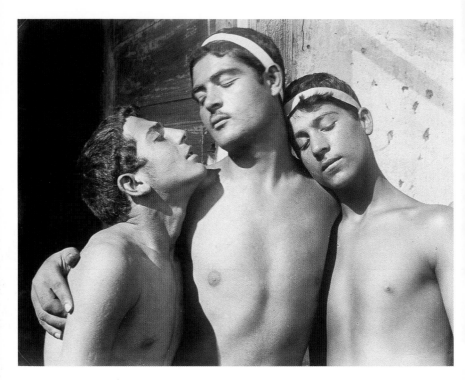

Wilhelm von Gloeden, c. 1900

 Wilhelm von Gloeden, c. 1900

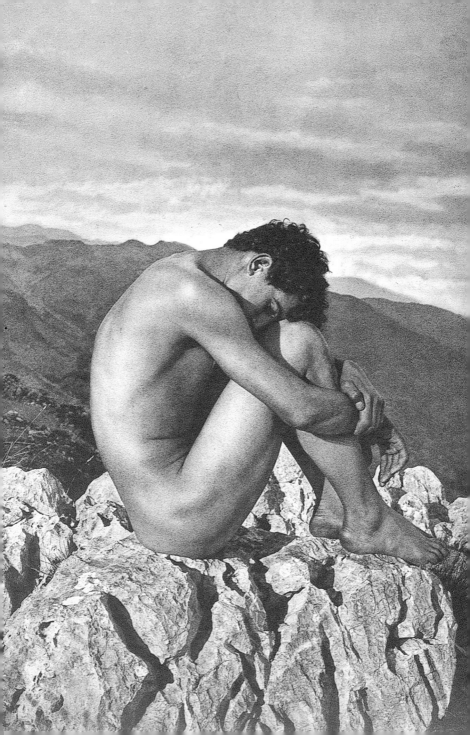

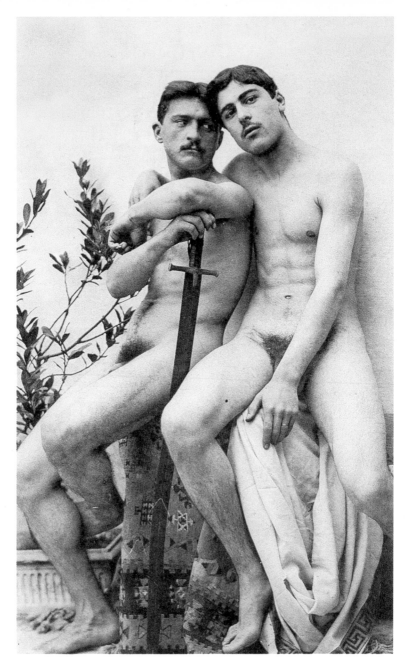

Arthur Schulz, c. 1900

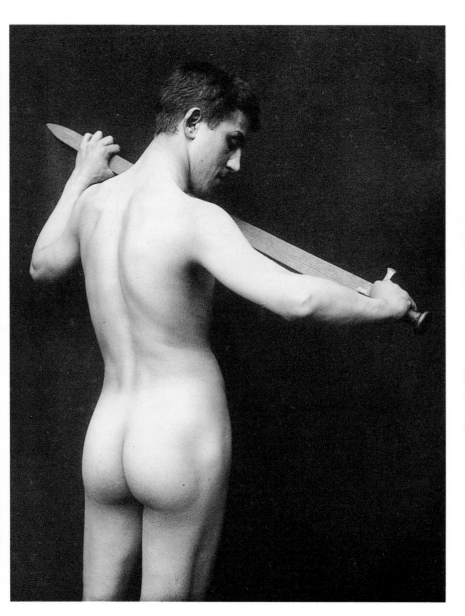

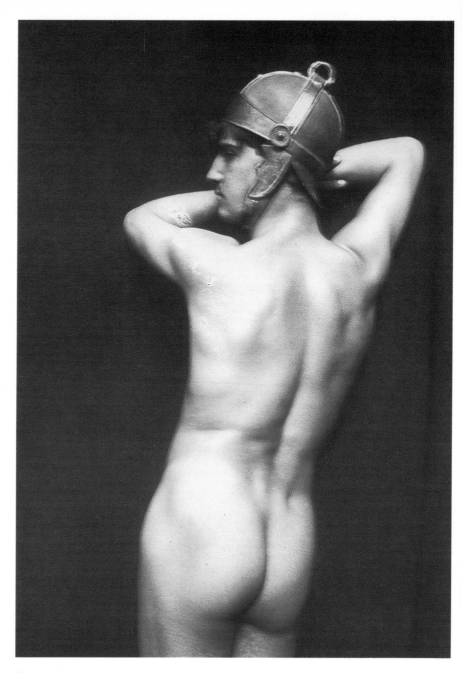

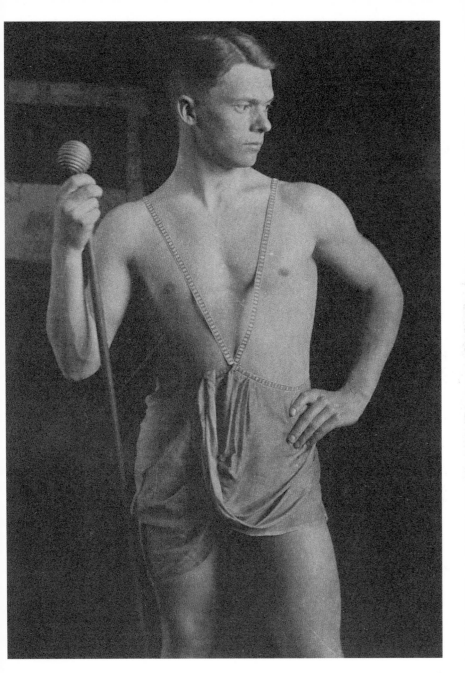

Theodor Hey, c. 1900

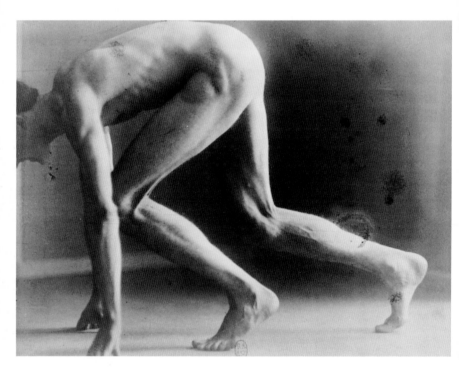

Jean-Léo Reutlinger, Hans Braun, coureur à pied, 1912

Paul Martin, Hackenschmidt, Russian Wrestler, c. 1910

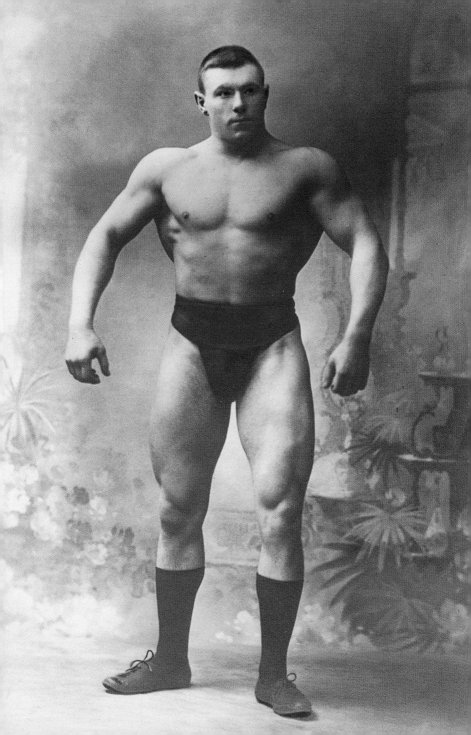

Frank Eugene Smith, c. 1914

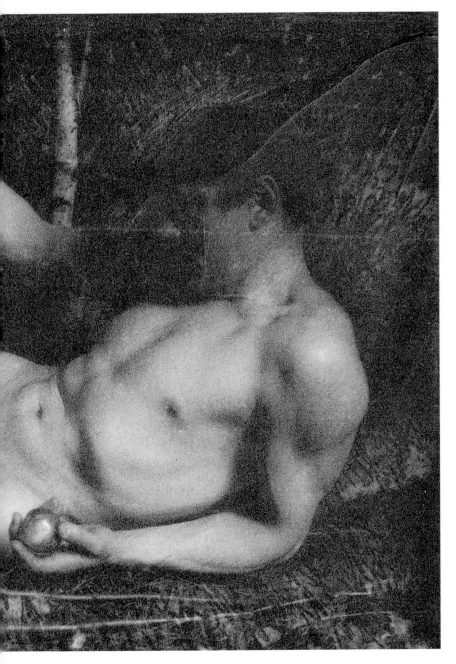

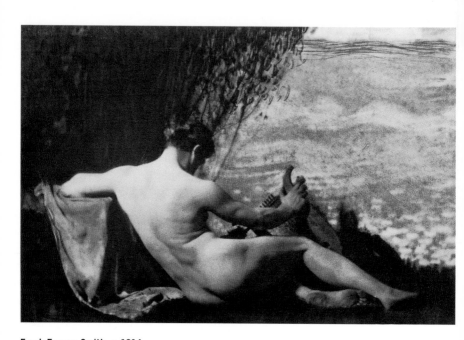

Frank Eugene Smith, c. 1914

Paul Pichier, Aktstudie zweier Jünglinge in romantischer Landschaft, 1890–1910

Edward Weston, The Bathing Pool, 1919

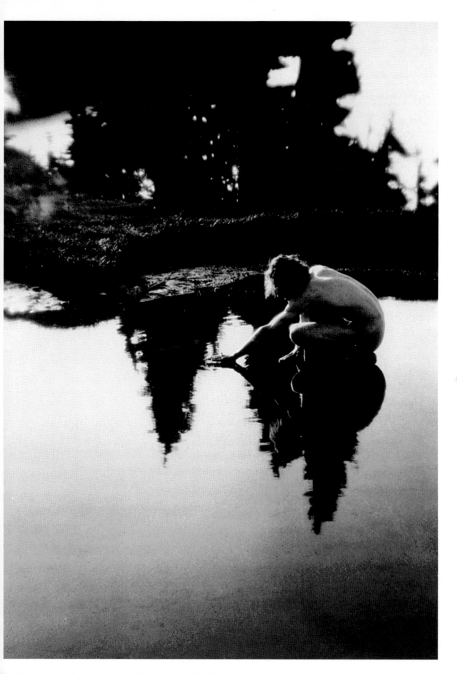

Imogen Cunningham, Roi on the Dipsea Trail, 1918 59

1920–1940

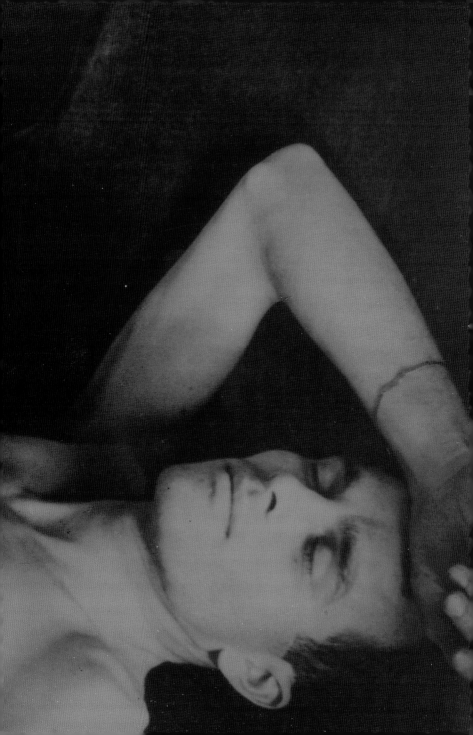

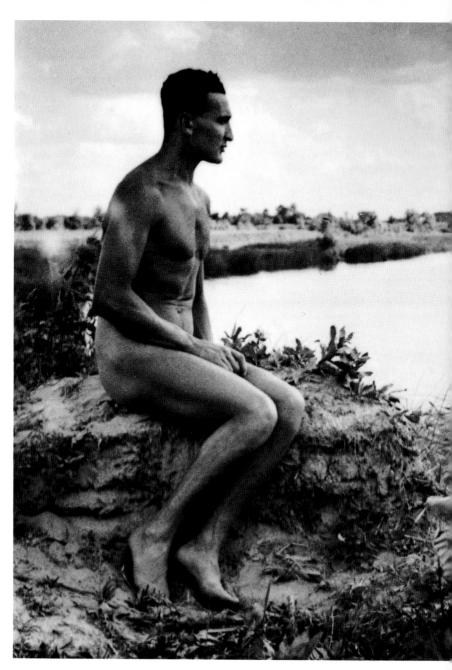

André Kertész, Duna Haraszti, May 30, 1920

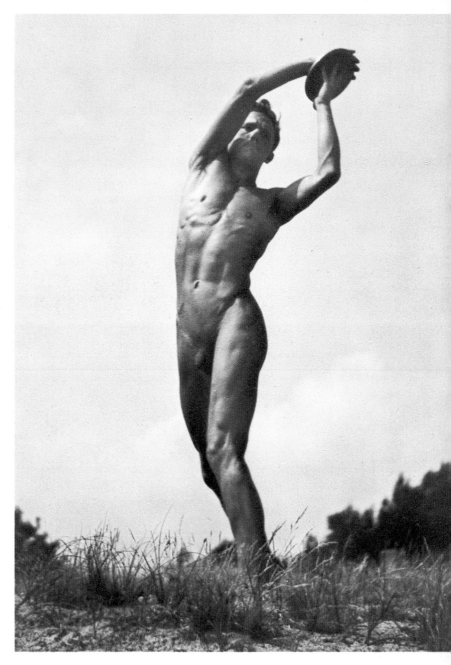

Kurt Reichert, c. 1935

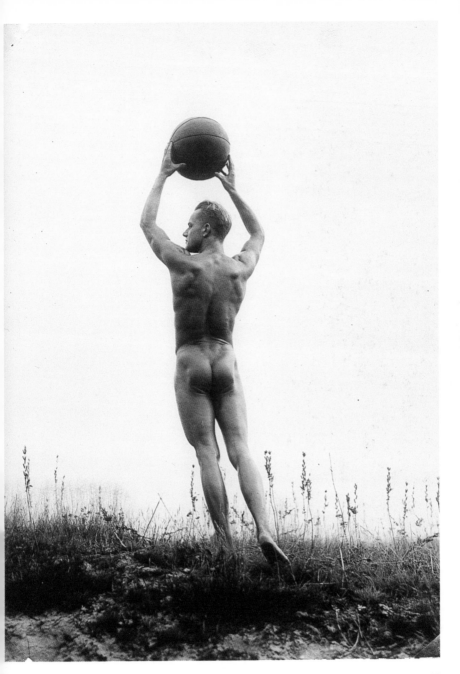

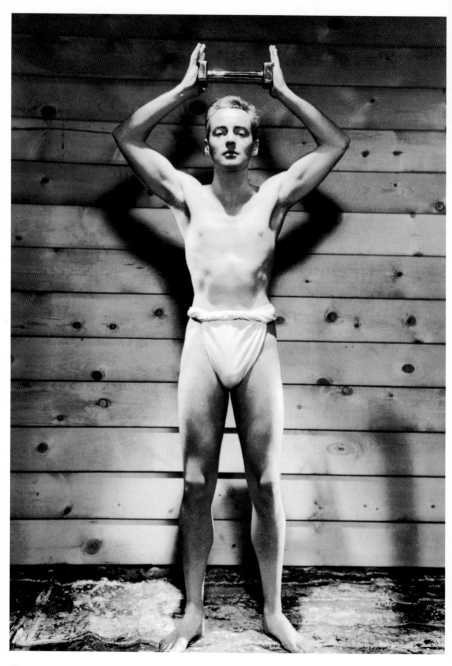

Man Ray, George Platt Lynes, c. 1928

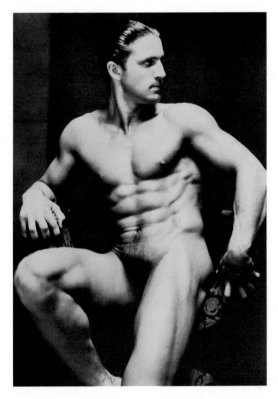

Edwin F. Townsend, Tony Sansone, c. 1930

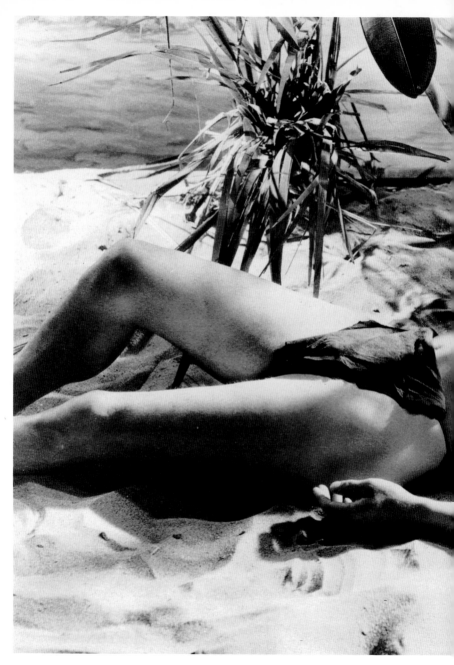

Cecil Beaton, Johnny Weissmüller, 1932

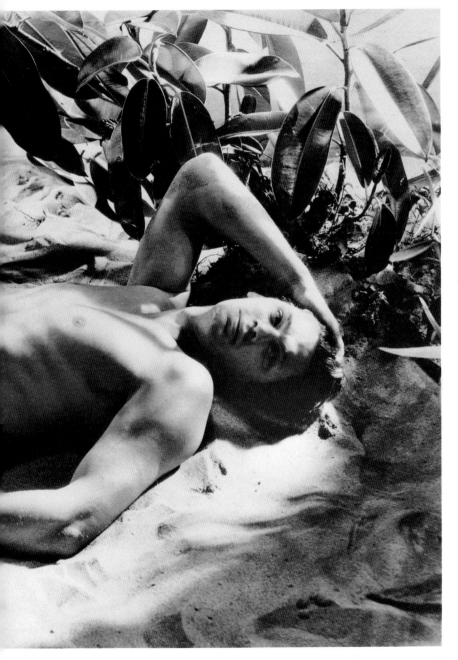

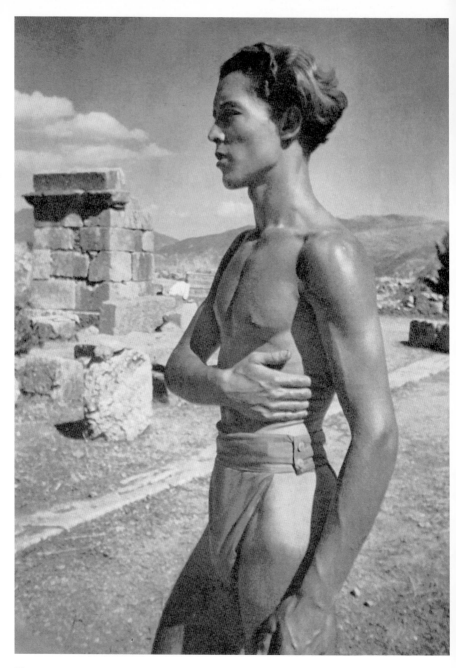

Leni Riefenstahl, Junger Grieche aus Pyrgos, 1936

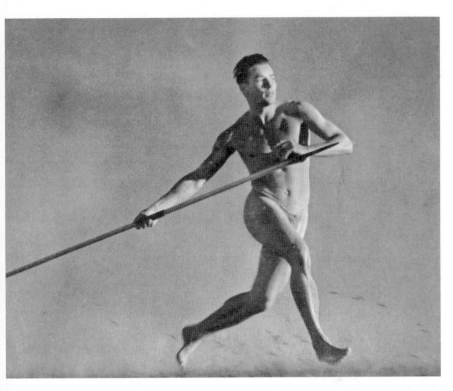

Leni Riefenstahl, Der Speerwerfer, 1936

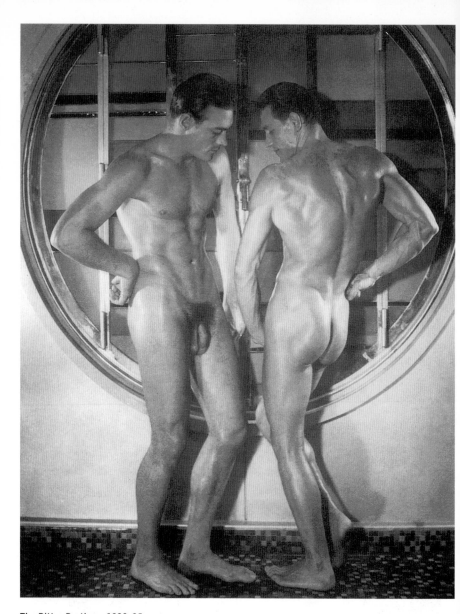

The Ritter Brothers, 1932–35

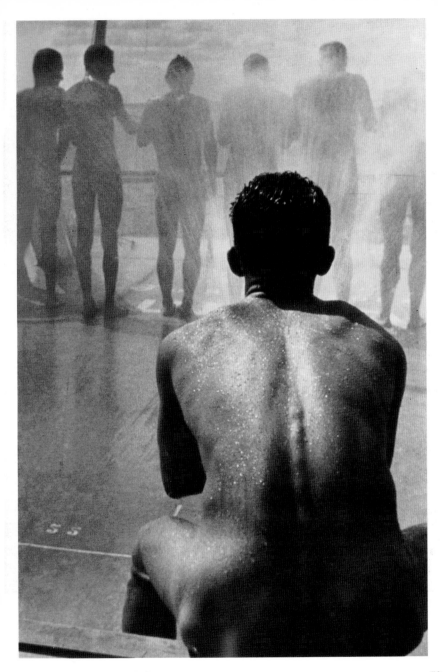

Boris Ignatovich, The Bath, 1935

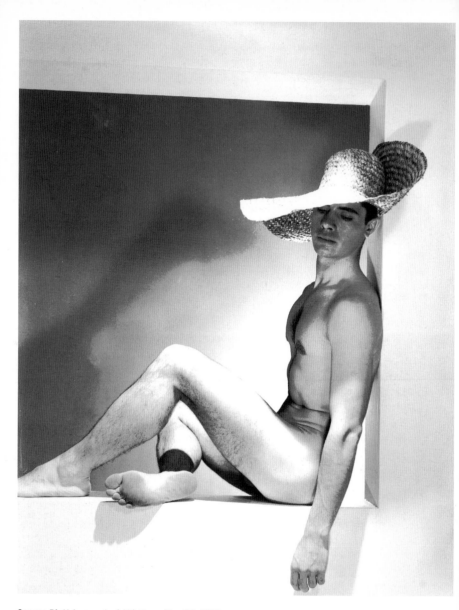

George Platt Lynes, José Mártinez, May 25, 1937

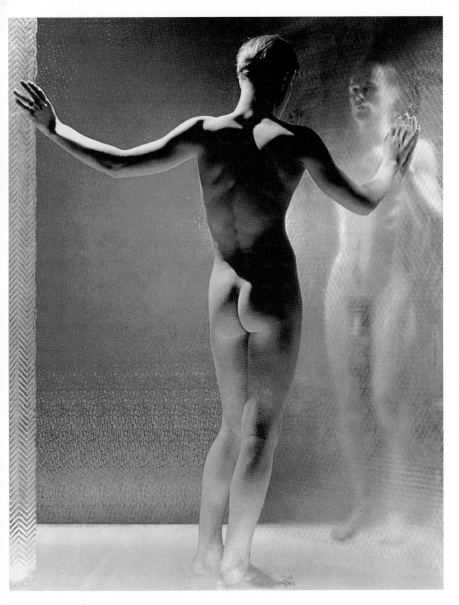

George Platt Lynes, James Ogle with Chester Nielsen in Foreground, 1937

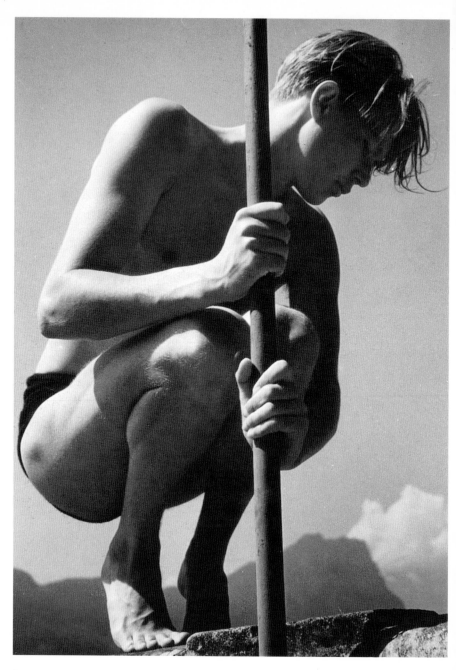

Herbert List, Ritti mit Angel, 1936

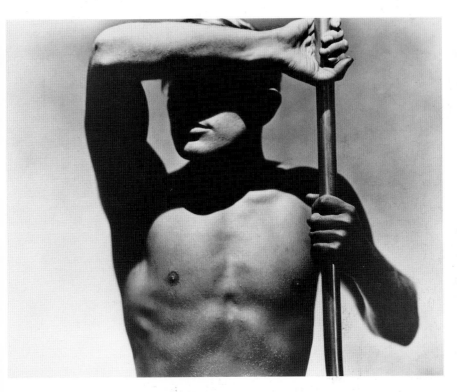

George Hoyningen-Huene, Horst P. Horst, 1931

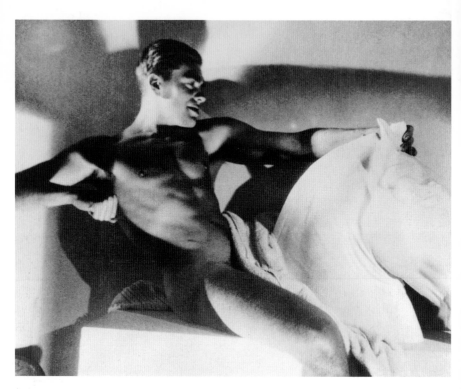

George Hoyningen-Huene, Horst P. Horst, 1932

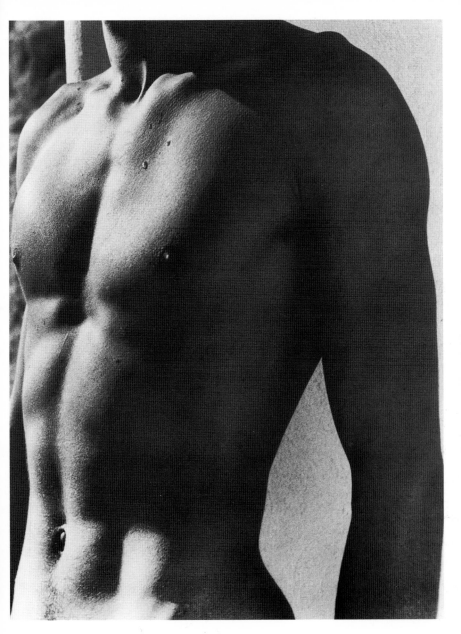

Herbert List, Torso, 1936

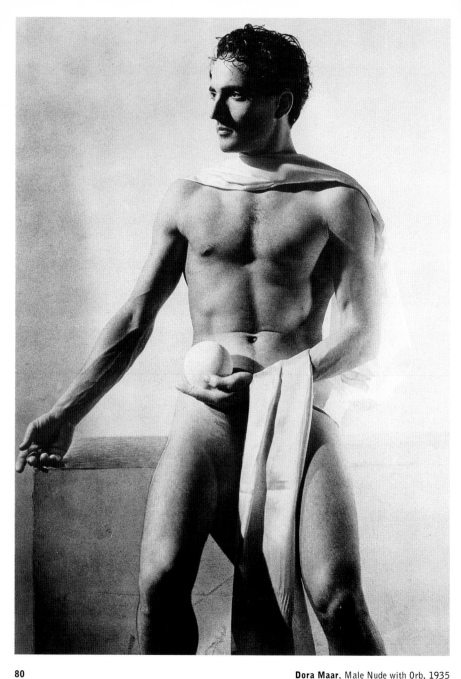

Dora Maar, Male Nude with Orb, 1935

J. Walter Collinge, Cypress and Stone/Ted Shawn, 1926

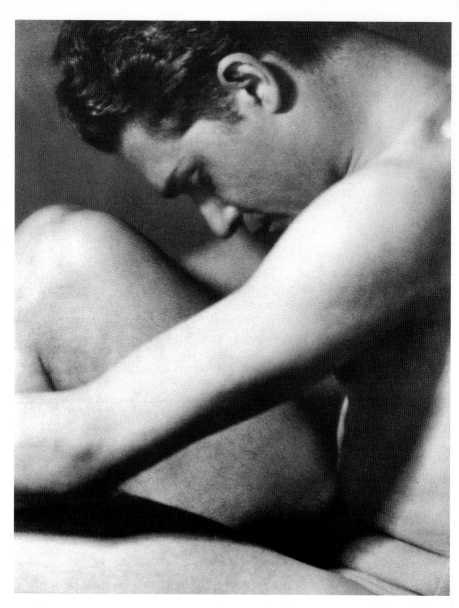

Laure Albin-Guillot, Untitled, c. 1930

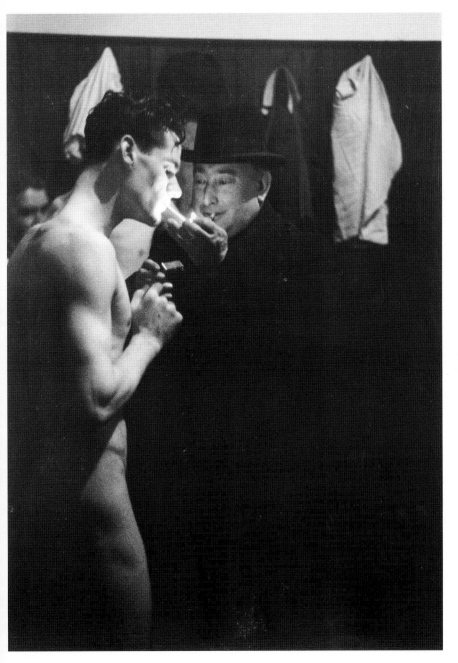

Humphrey Spencer, Newcastle United Football Club Changing Room, 1938

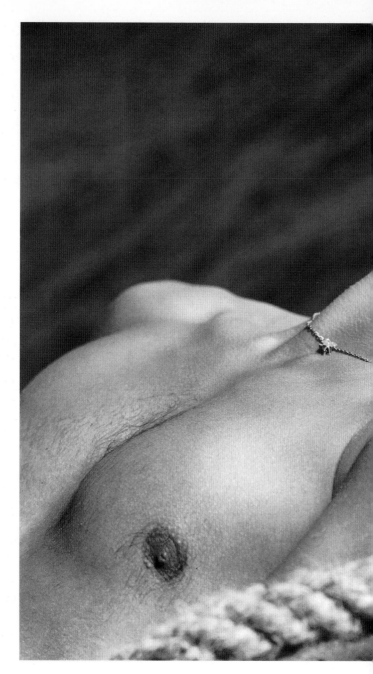

Raymond Voinquel, Louis Jourdan, 1939

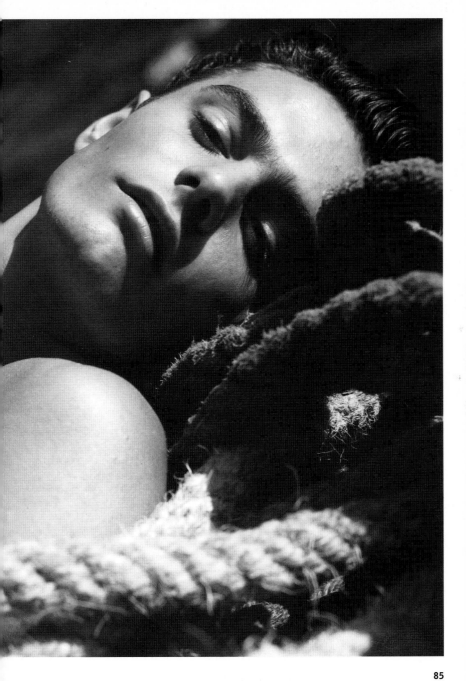

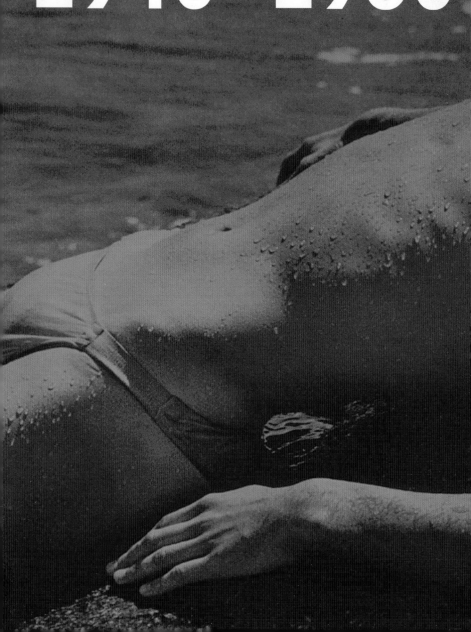

1940–1960

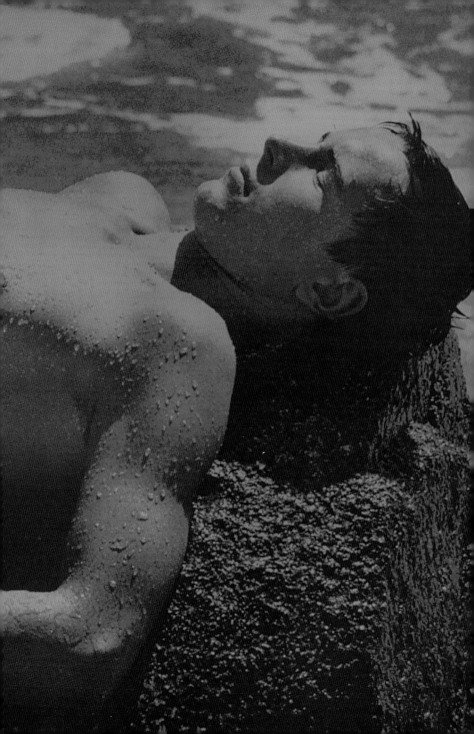

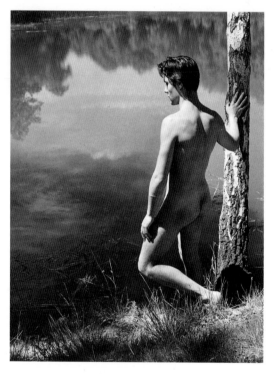

Raymond Voinquel, Narcisse.
Projet pour les « Fragments du Narcisse » de Paul Valéry, 1940

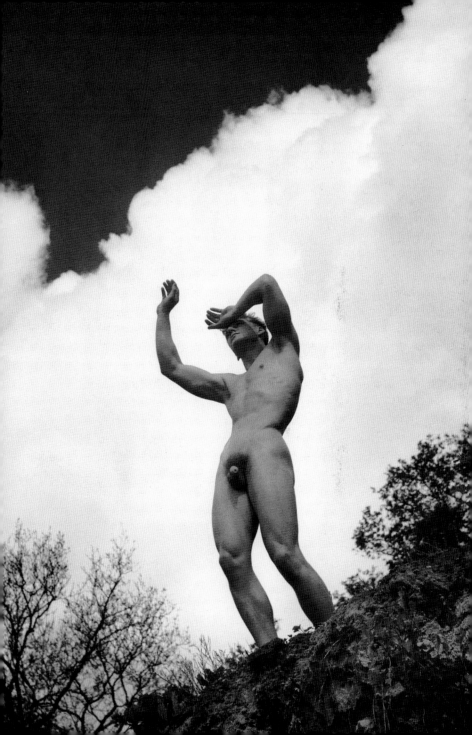

Minor White, Untitled, from the Sequence "The Temptation of St. Anthony Is Mirrors", 1948

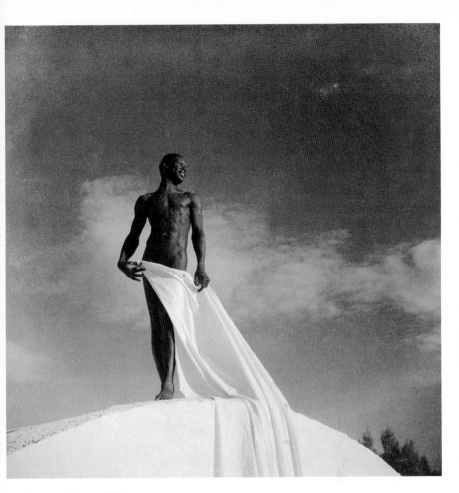

Cecil Beaton, Morocco, 1958

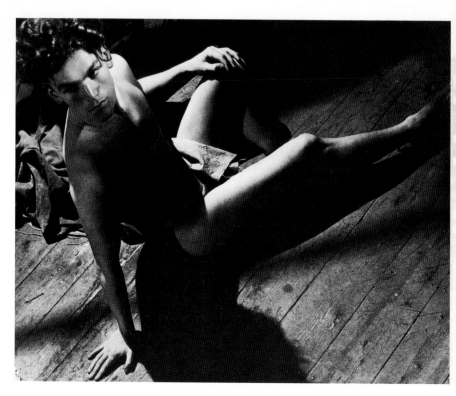

Angus McBean, c. 1950

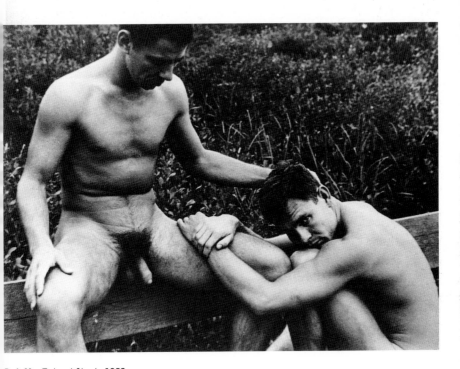

PaJaMa, Ted and Chuck, 1953

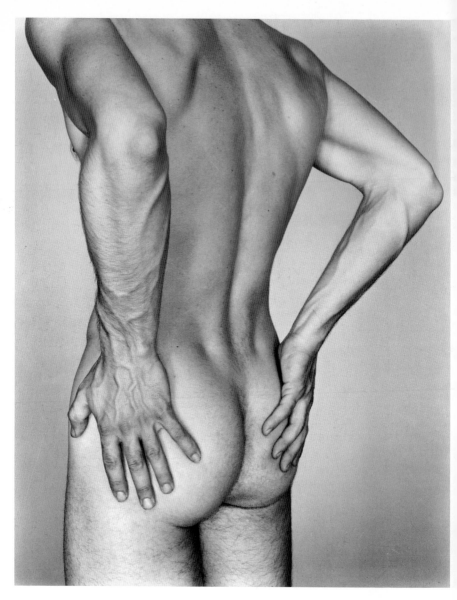

George Platt Lynes, Ted Starkowski, May 19, 1955

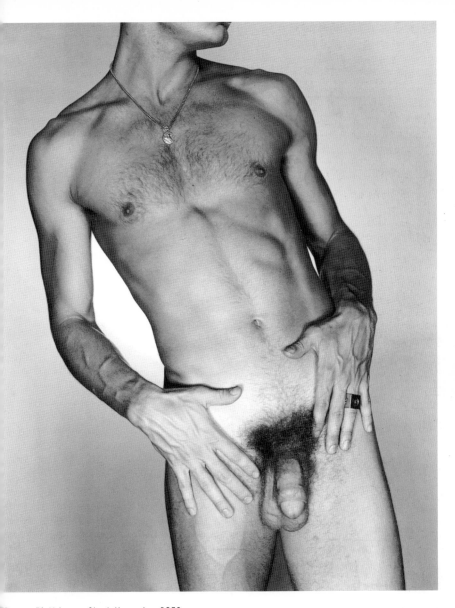

George Platt Lynes, Chuck Howard, c. 1950

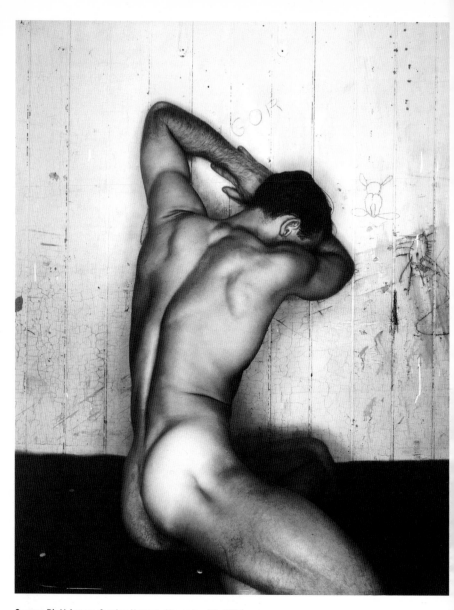

George Platt Lynes, Gordon Hanson, November 11, 1954

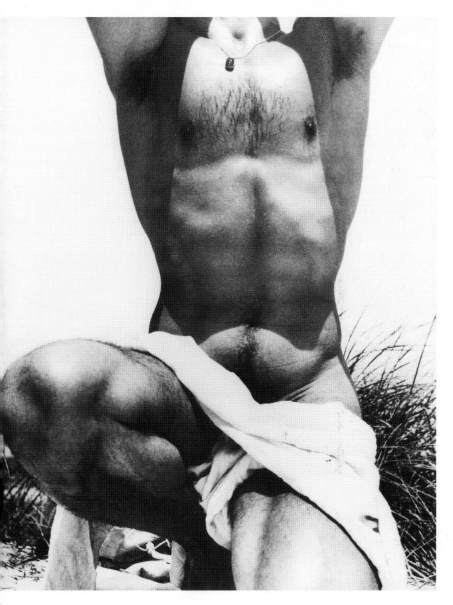

George Platt Lynes, Francisco Moncion, c. 1948

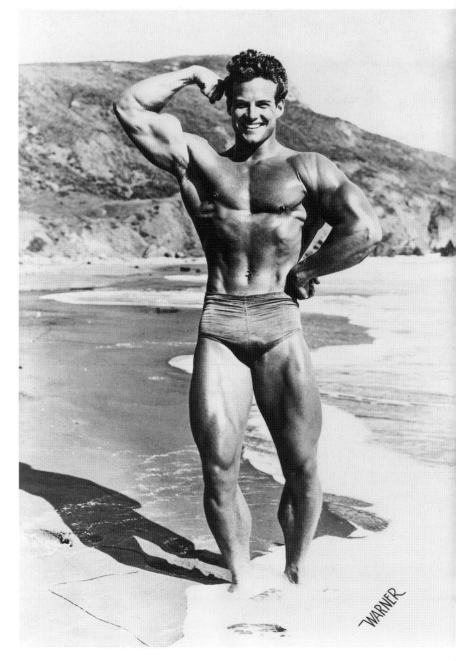

Russ Warner, Steve Reeves, 1947

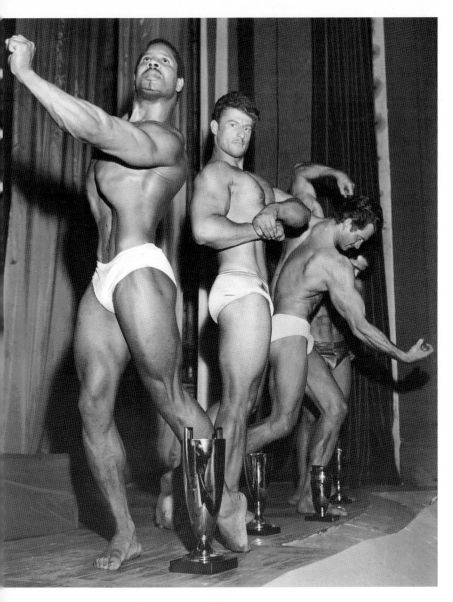

Anonymous, French Bodybuilders Competition, c. 1955

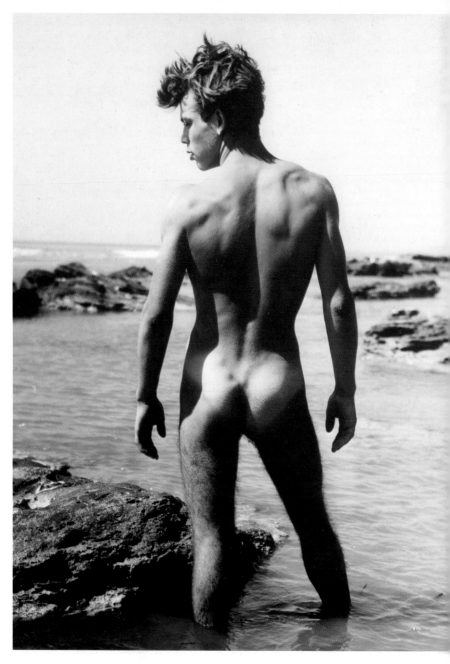

Konrad Helbig, Sicily, c. 1950–55

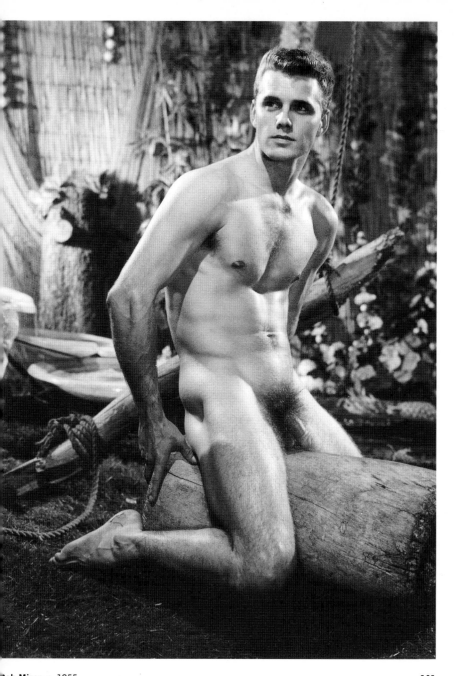

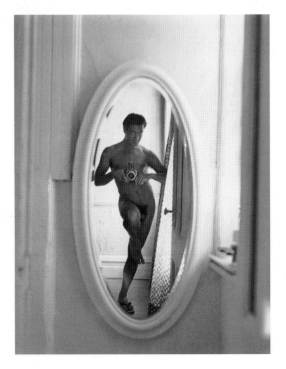

Emerick Bronson, Self-Portrait, 1956

Herbert Tobias, Muskel-Träume, 1960

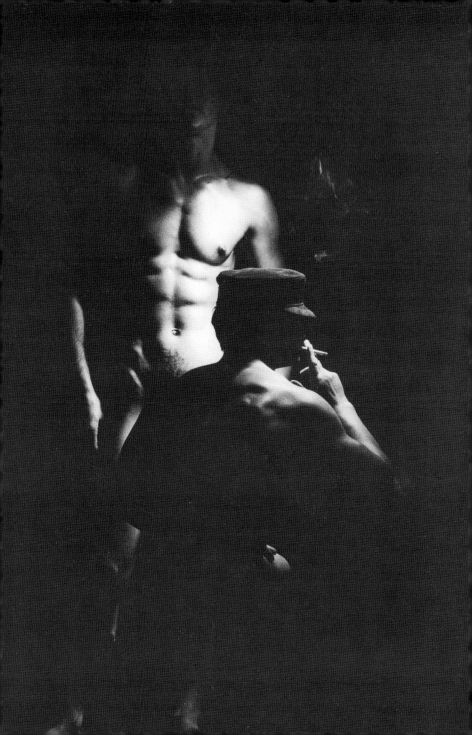

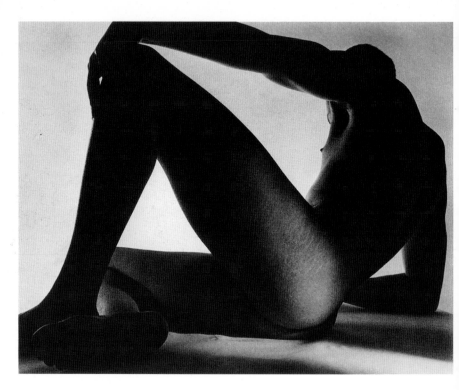

Horst P. Horst, Tchelitchew Nude (reclining), 1952

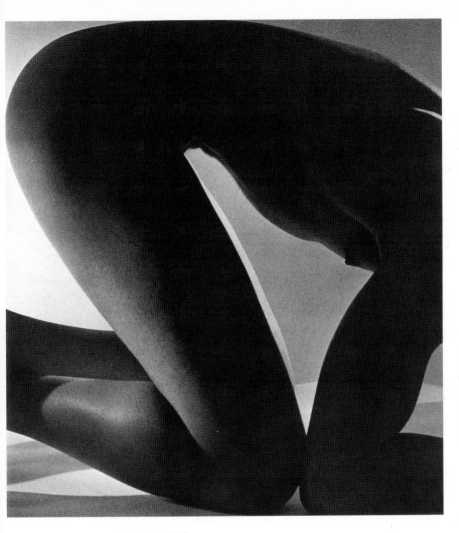

Horst P. Horst, Triangles – Male Nude, 1952

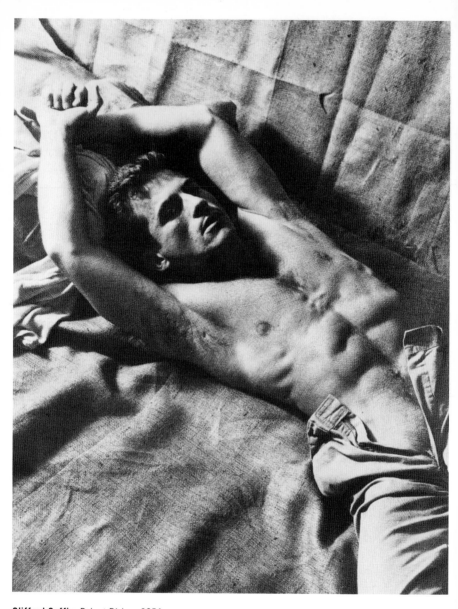

Clifford Coffin, Robert Bishop, 1954

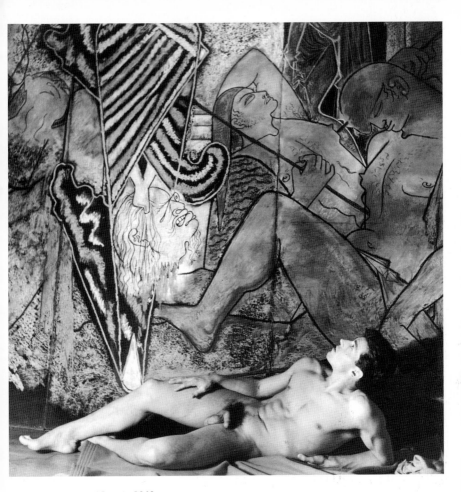

Herbert List, Edouard Dermit, 1948

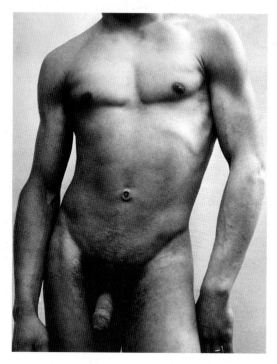

Jo von Kalckreuth, c. 1955–60

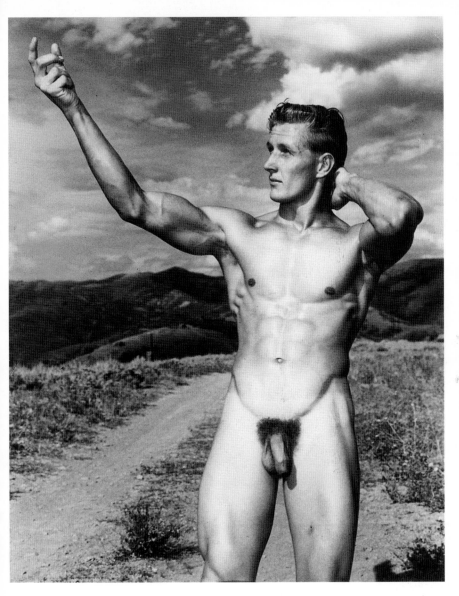

Bruce of Los Angeles, c. 1950

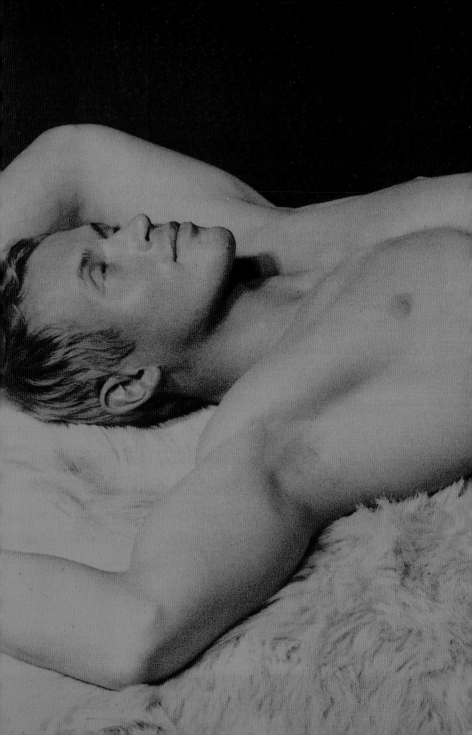

1960–1980

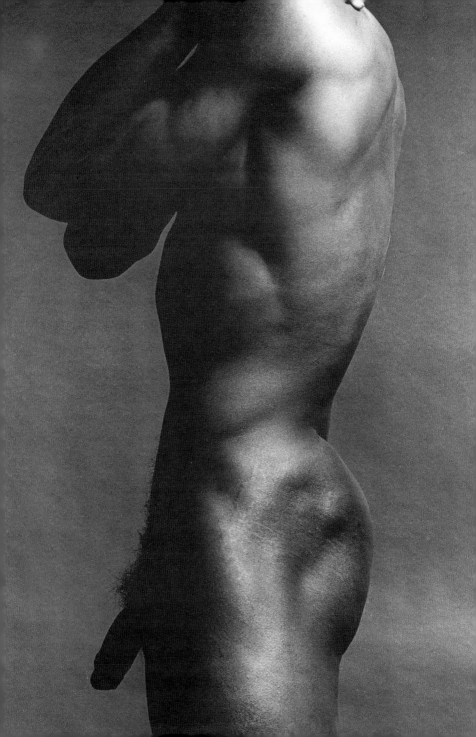

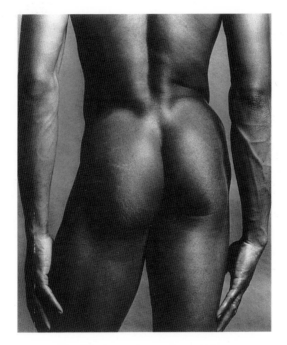

Ken Haak, Black Buttocks and Lower Back, 1968

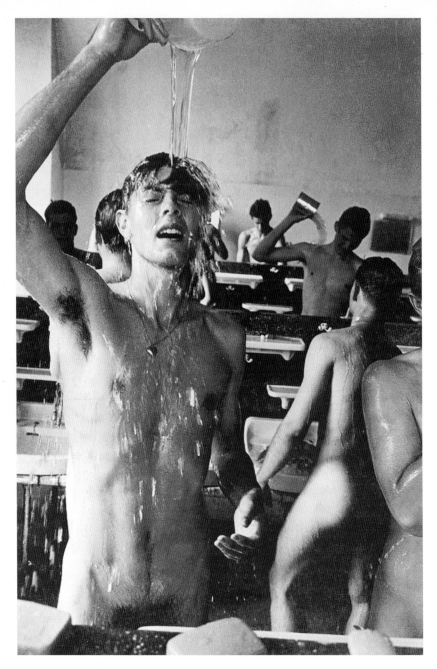

Will McBride, Schloß Salem, Waschung, 1962

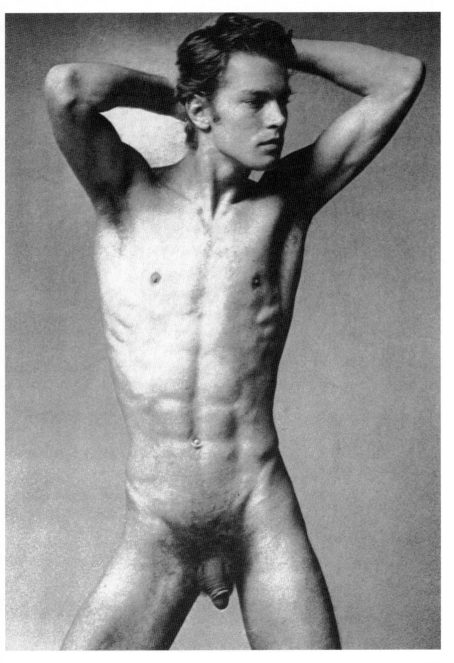

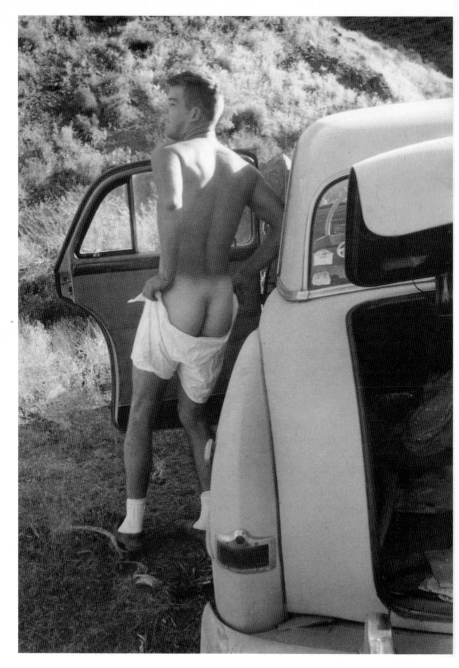

Clifford Baker, Nevada Camping Trip, September 1958

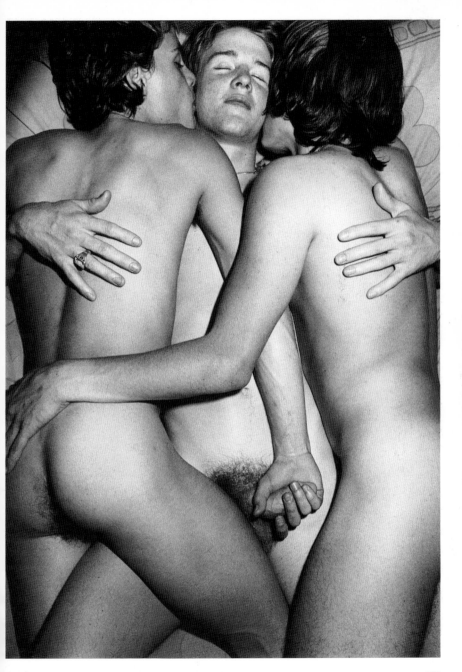

Clifford Baker, Jeff, David and Marty, 1978

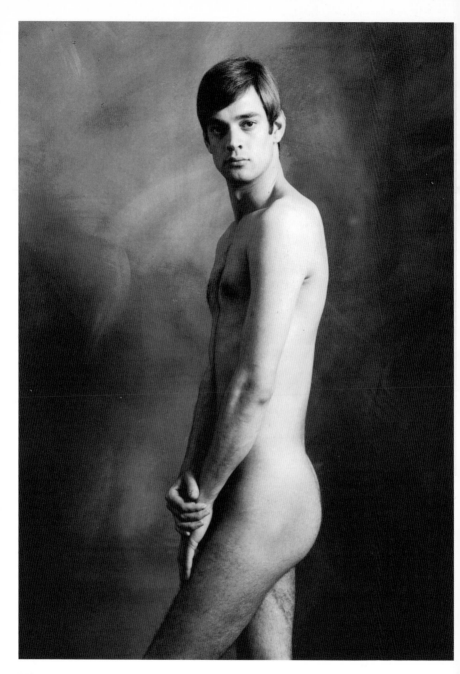

Jean-François Bauret, Selimaille, 1967

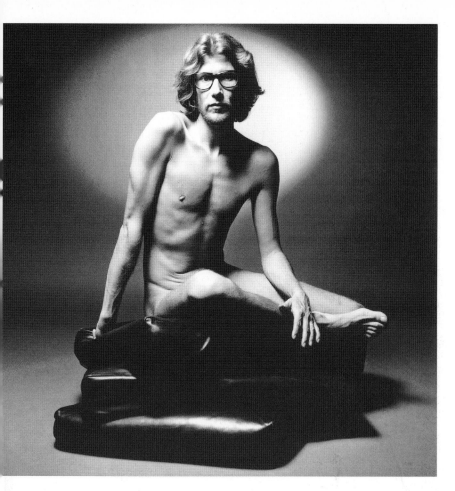

Jeanloup Sieff, Yves Saint-Laurent, 1971

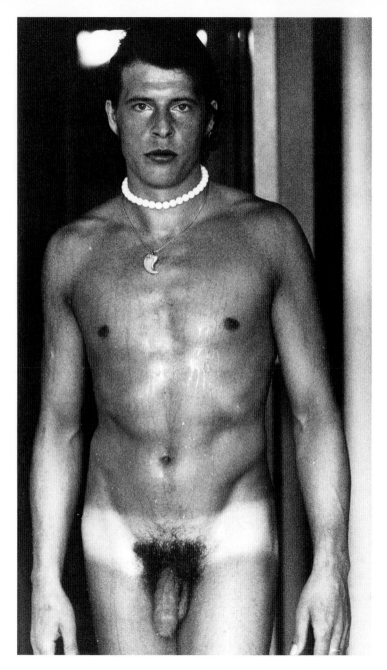

Charlotte March, In Tür mit Halskette, 1977

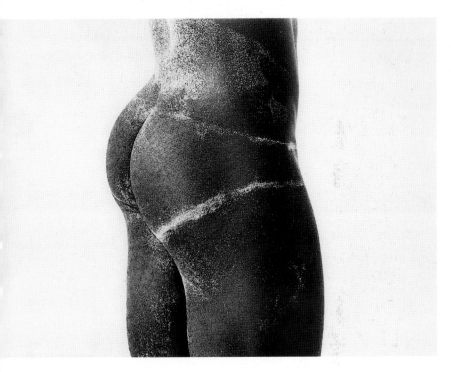

Wolfgang von Wangenheim, Aüs der Serie Schwarz, 1976

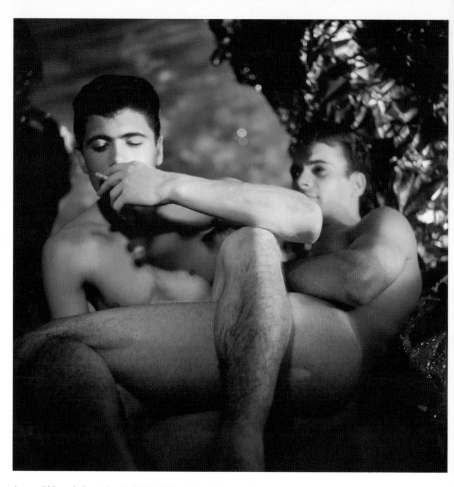

James Bidgood, Sand Castle (Bobby & Jay) One. Fifteen, 1960s

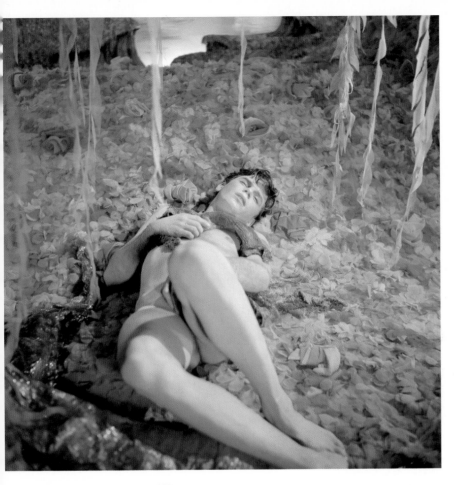

James Bidgood, Willow Tree Three, 1960s

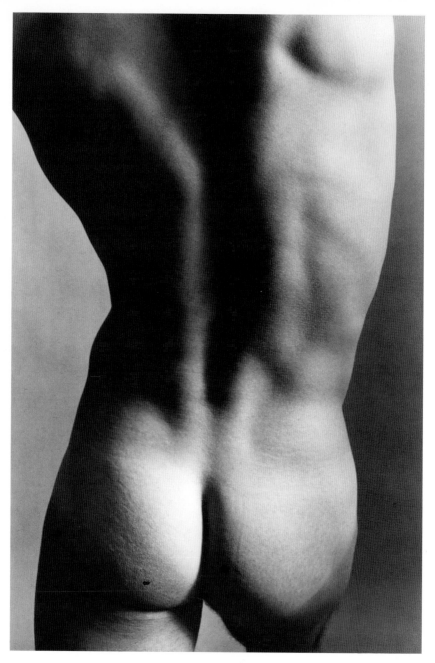

Eva Rubinstein, Man's Nude Back, November 1971

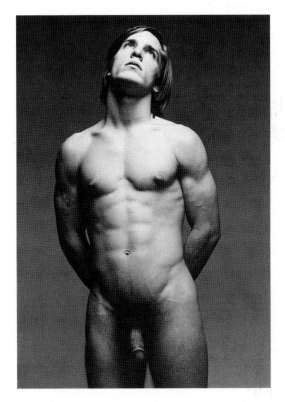

Francesco Scavullo, Joe Dallesandro, 1968

Dianora Niccolini, "The Chest", from the Series "Male Nude", 1975

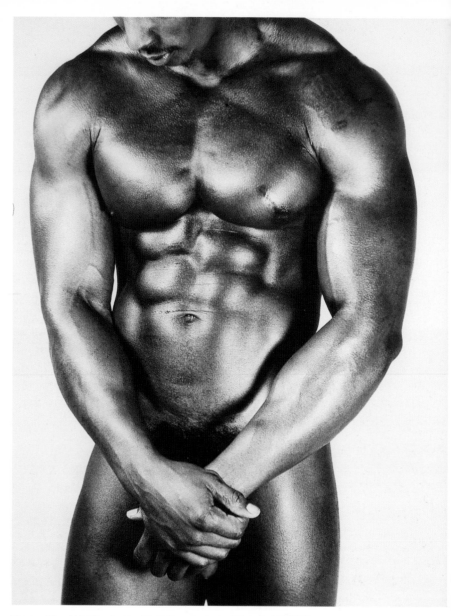

Dianora Niccolini, "The Bodybuilder", from the Series "Male Nude", 1975

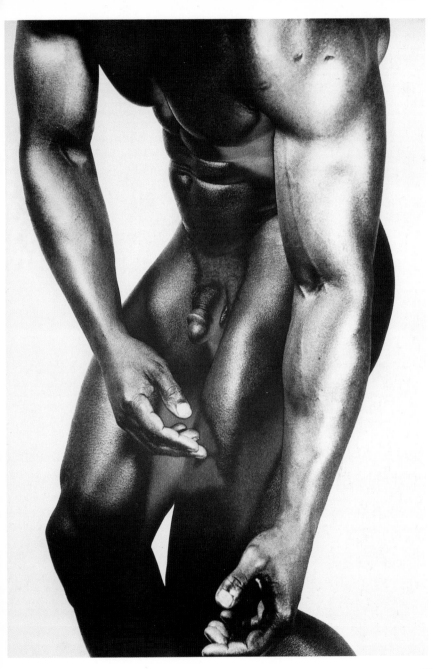

Dianora Niccolini, "The Bodybuilder", from the Series "Male Nude", 1975

Andy Warhol, Torso, 1977

Andy Warhol, Torso, 1977

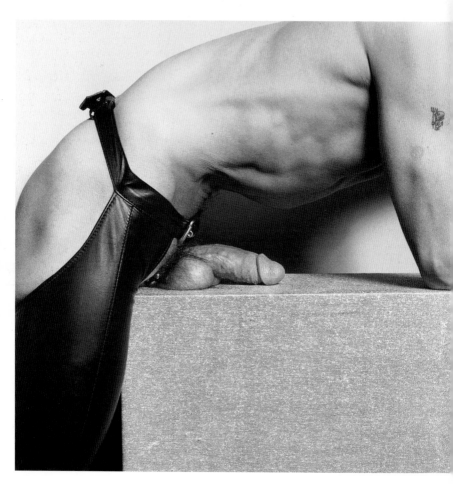

Robert Mapplethorpe, Marc Stevens (Mr. 10 1/2), 1976

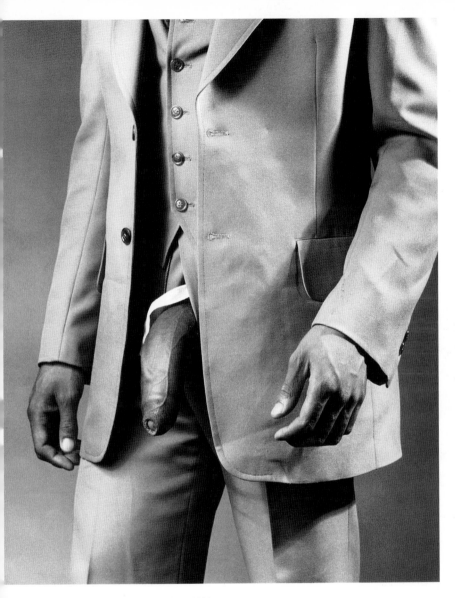

Robert Mapplethorpe, Man in Polyester Suit, 1980

1980 to the Present

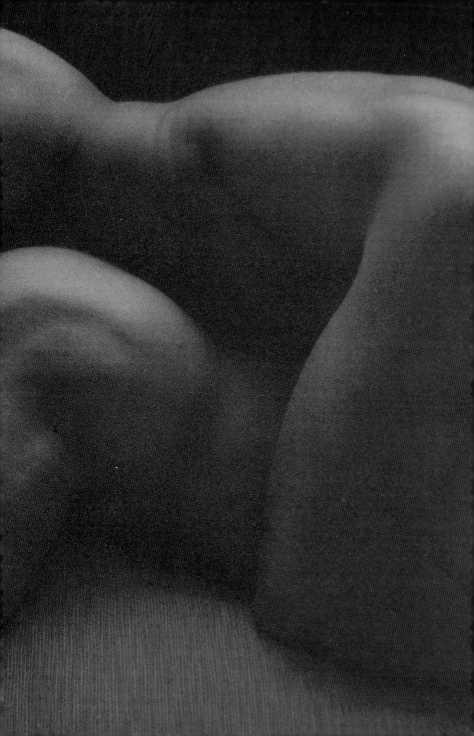

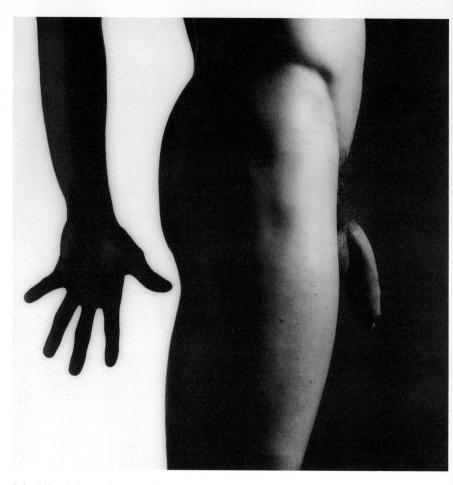

Robert Mapplethorpe, Untitled, 1981

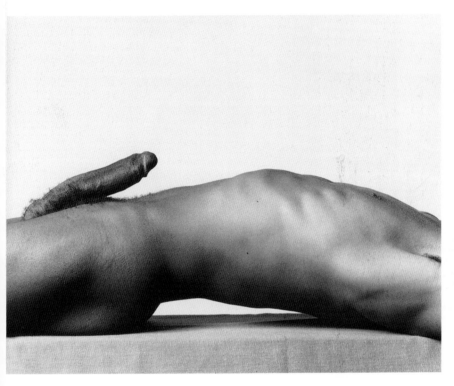

Robert Mapplethorpe, Christopher Holly, 1980

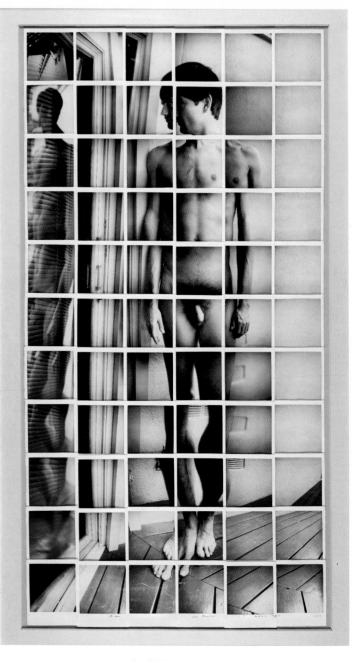

David Hockney, Brian, Los Angeles, 21st March 1982

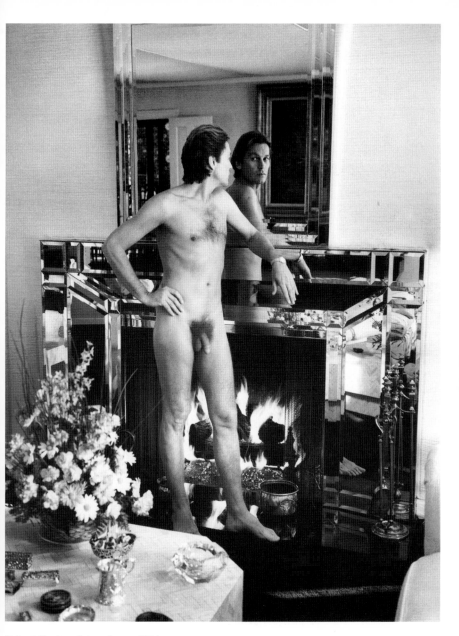

Helmut Newton, Helmut Berger, 1984

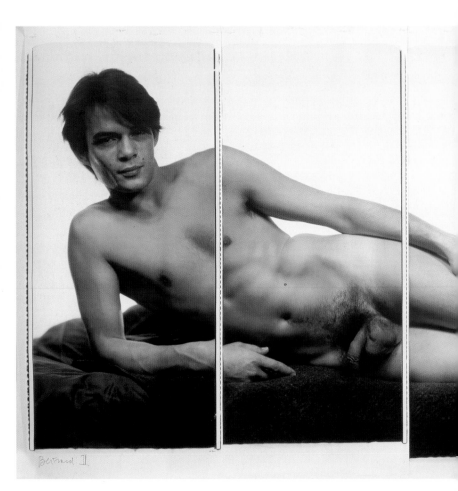

Chuck Close, Bertrand 2, 1984

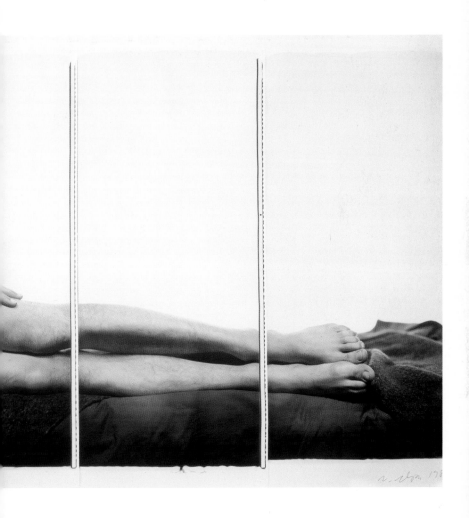

141

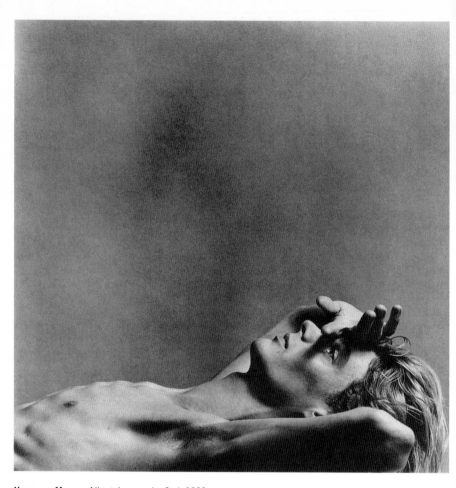

Hans van Manen, Albert Jan van der Stel, 1983

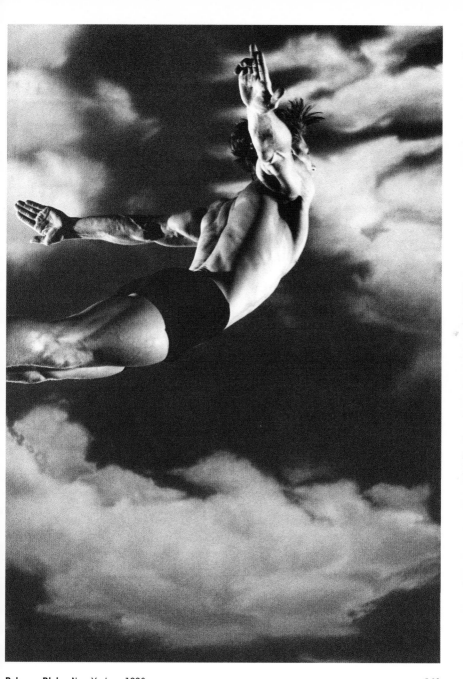

Rebecca Blake, New York, c. 1990

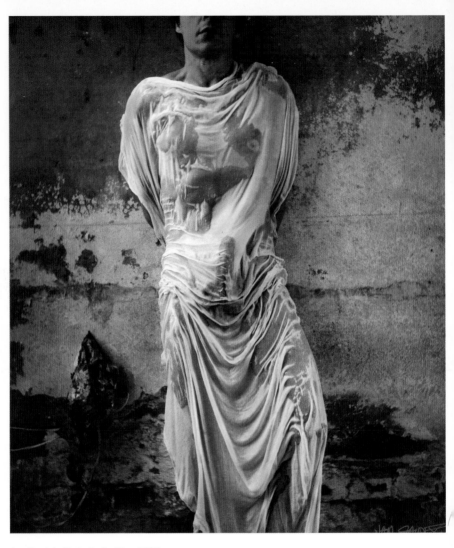

Jan Saudek, Portrait of a Man, 1984

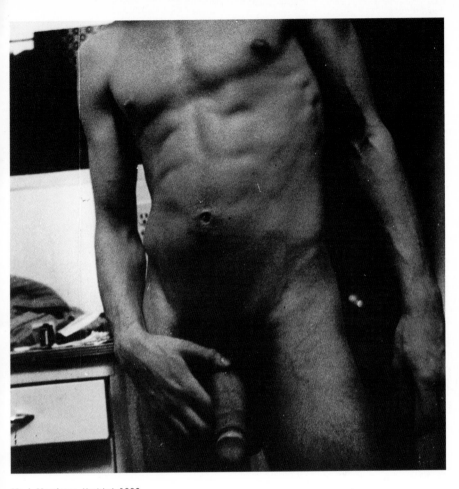

Mark Morrisroe, Untitled, 1982

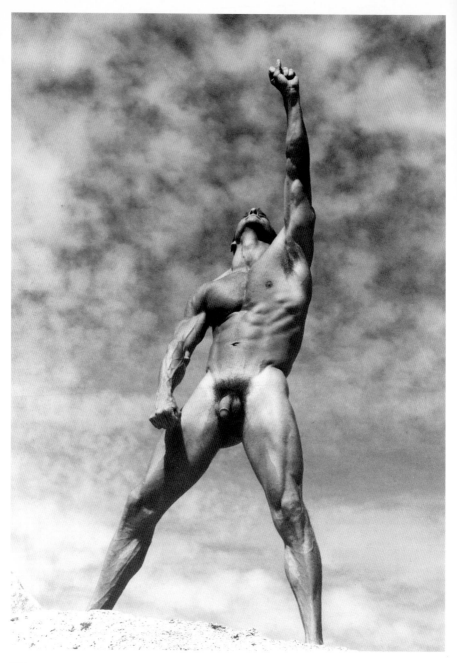

Jeff Palmer, Victory, 1992

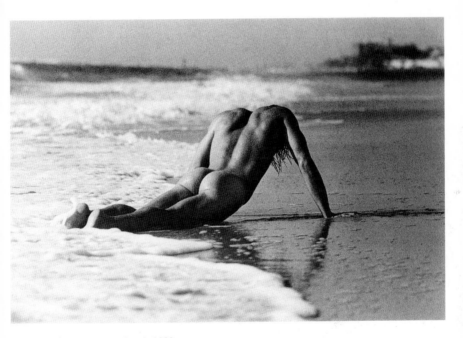

David Vance, Nude Man on Beach, 1990

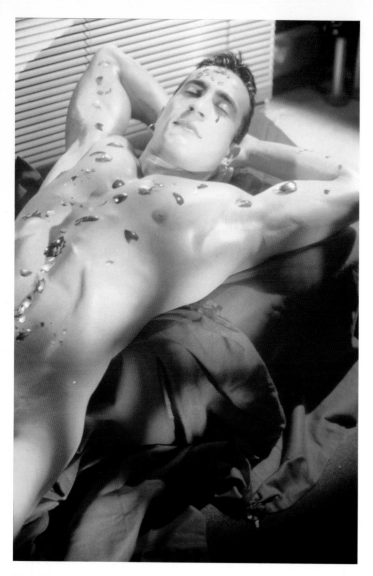

Patrick Sarfati, Sleeping Beauty, 1990

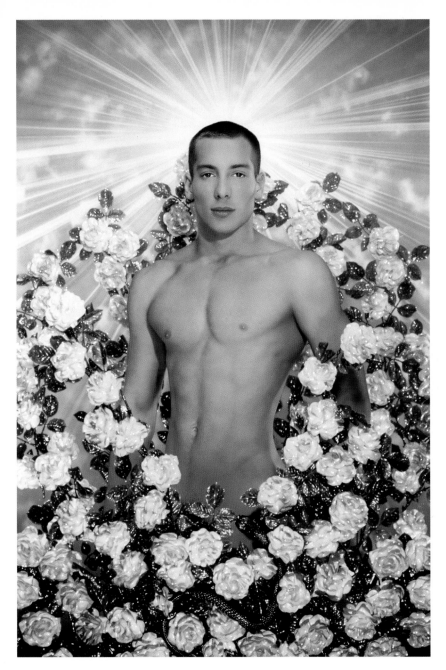

Pierre et Gilles, La Tentation d'Adam – Johan, 1996

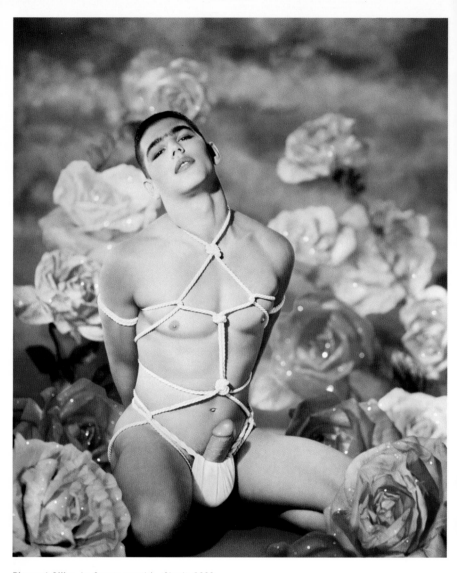

Pierre et Gilles, Le Garçon attaché – Charly, 1993

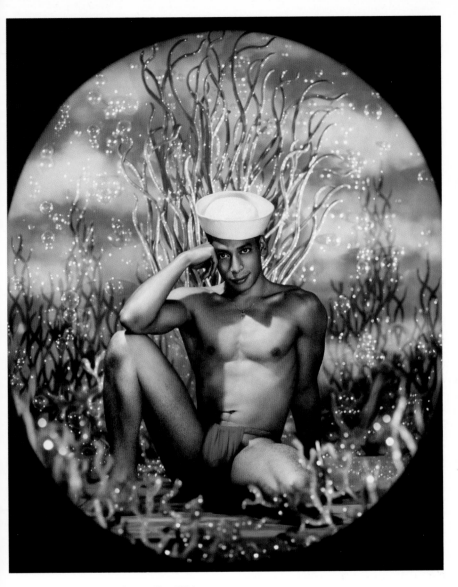

Pierre et Gilles, Le Marin Rêveur – Ken, 1994

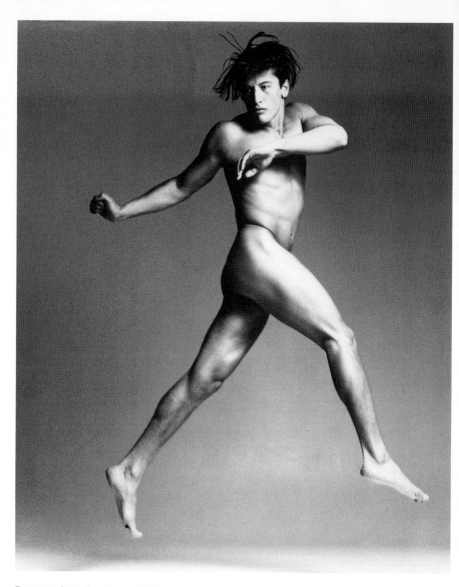

Francesco Scavullo, Edwardo, 1993

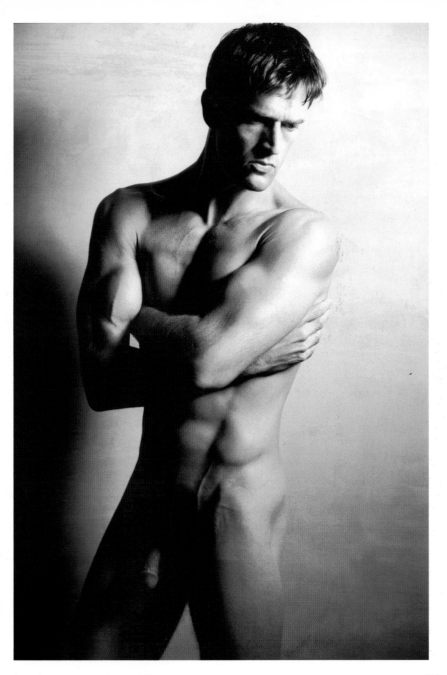

Greg Gorman, Rupert Everett, 1995

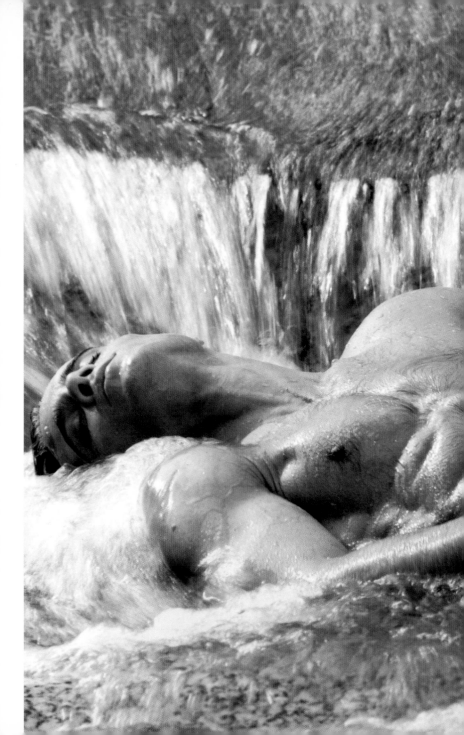

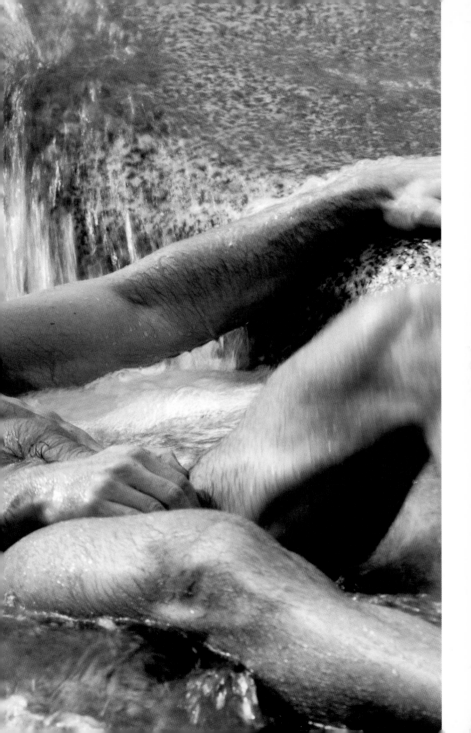

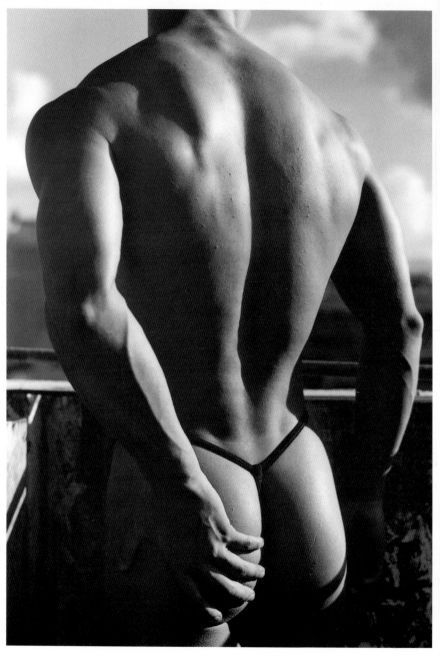

◀ **Greg Gorman**, Scott in Waterfall, 1990

Daniel Hernández, Dorso, 1993

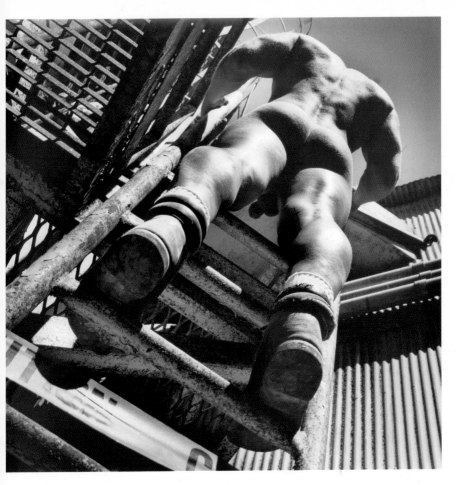

Arthur Tress, Man on Ladder, 1995

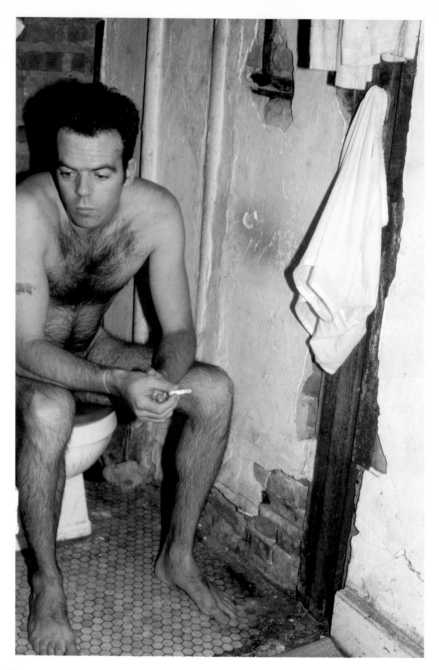

Nan Goldin, Brian on the Toilet, NYC, 1982

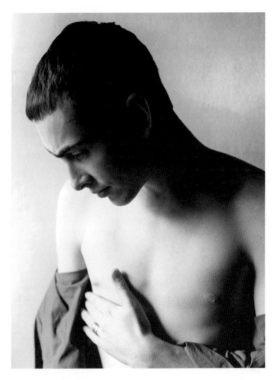

Wolfgang Tillmans, Barnaby, 1991

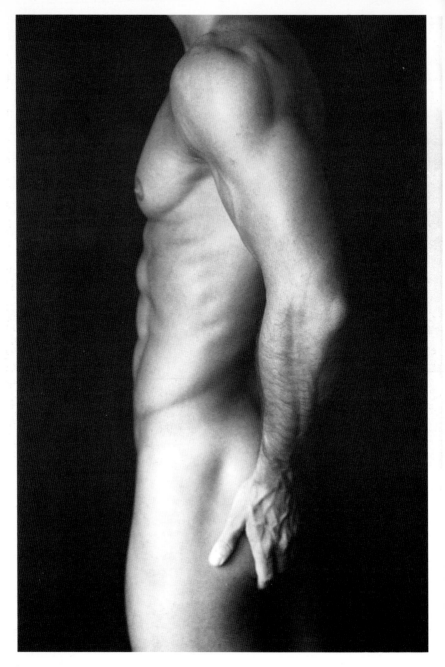

Dick Sweet, 1996

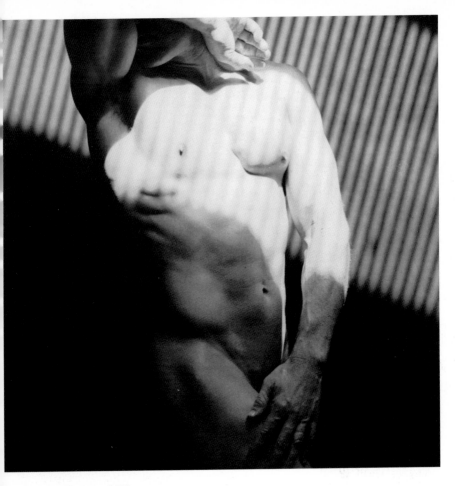

Harriet Leibowitz, Larry, 1996

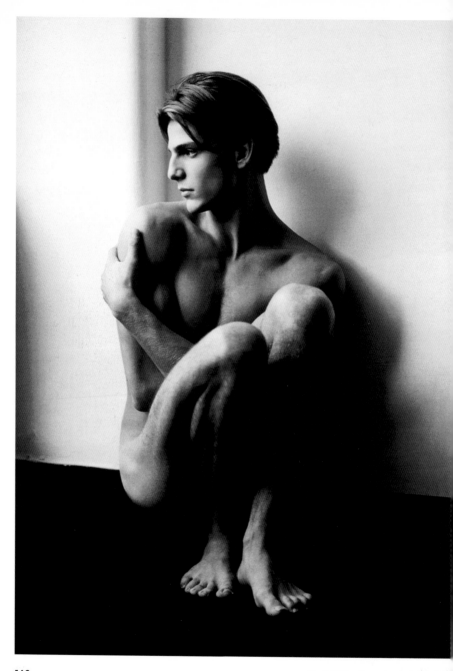

Herb Ritts, Stephano Seated, 1985

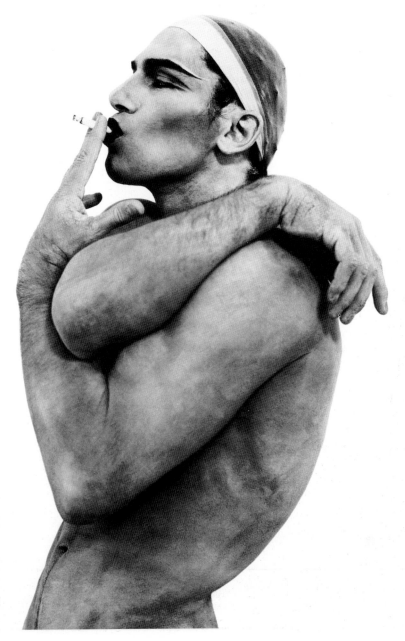

Herb Ritts, Vladimir I, 1990

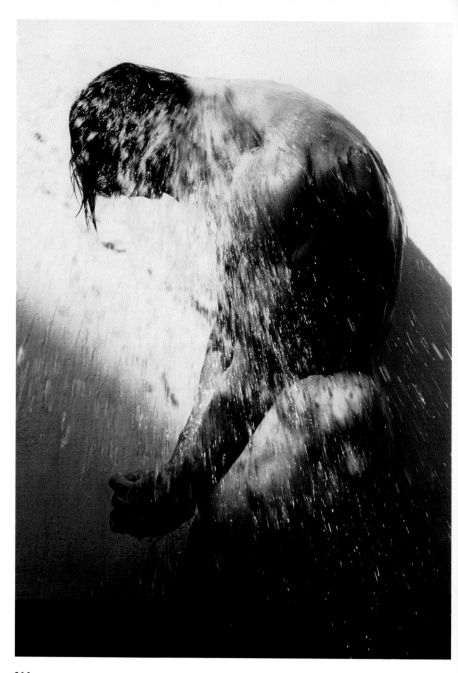

Herb Ritts, Splash, 1989

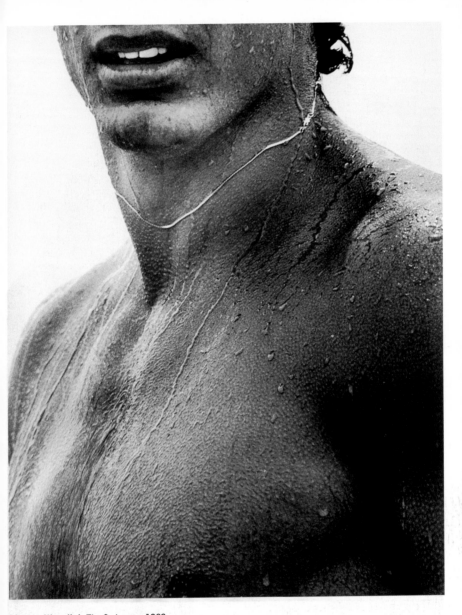

Dianora Niccolini, The Swimmer, 1983

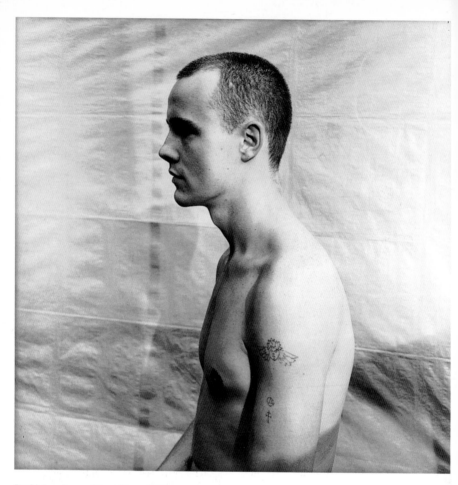

David Armstrong, Steven Swan, 1983

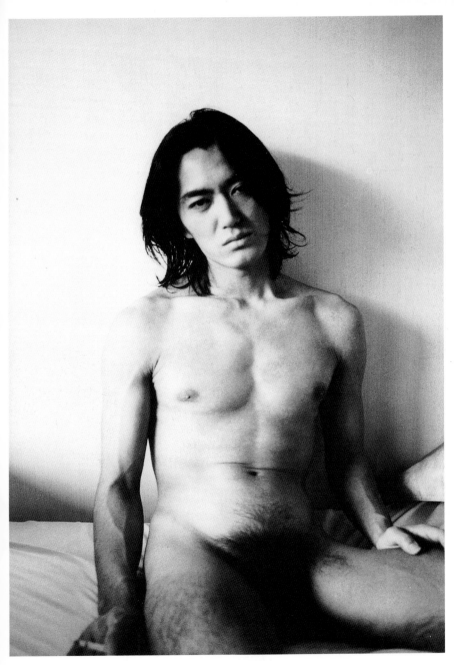

Sakiko Nomura, Untitled, from the Series "Naked Time", 1997

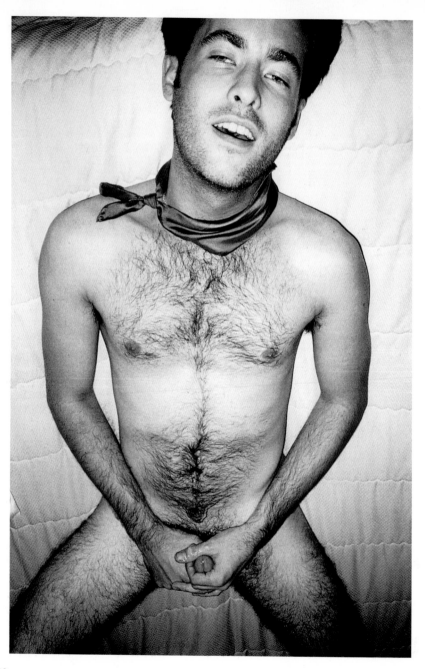

Terry Richardson, Christian Jerking off

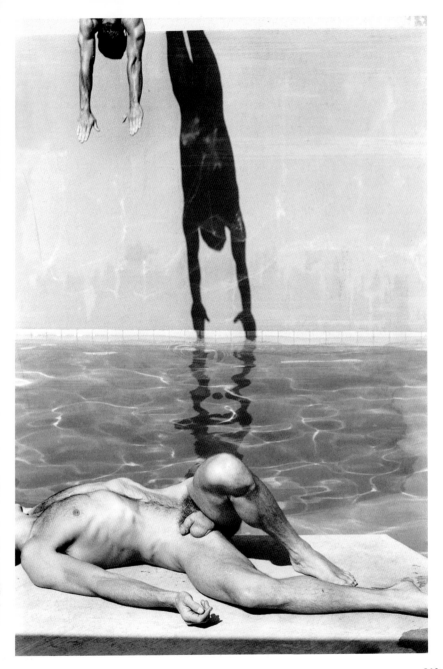

Tom Bianchi, 1990

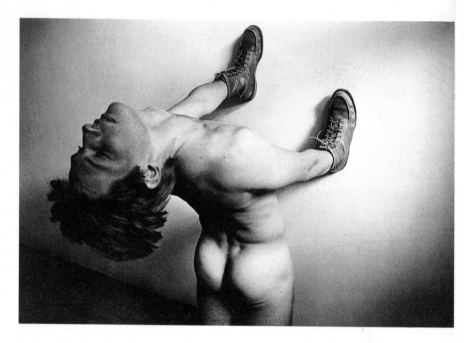

The unfortunate man could not touch the one he loved. It had been forbidden by law. Slowly his fingers became toes and his hands became feet. He ~~now~~ now began to wear shoes on his hands to disguise his pain. It never occurred to him to break the law.

Duane Michals, 1978

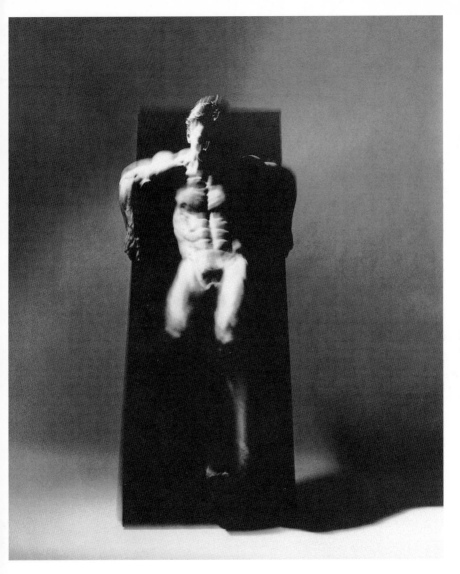

Victor Skrebneski, Four Studies of Figure in Movement Ascending and Descending a Black Velvet Monolith, 1990

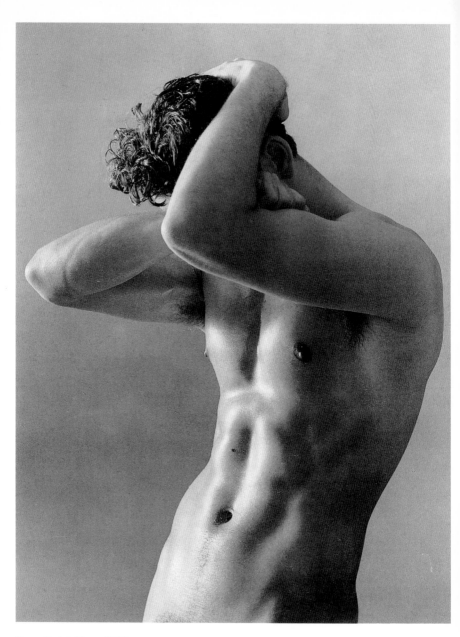

Bruno Benini, Simon, 1994

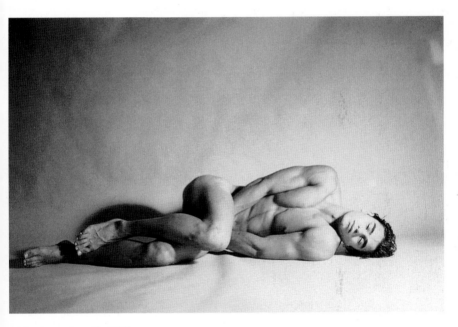

Adrian Jones, Carmillo, 1997

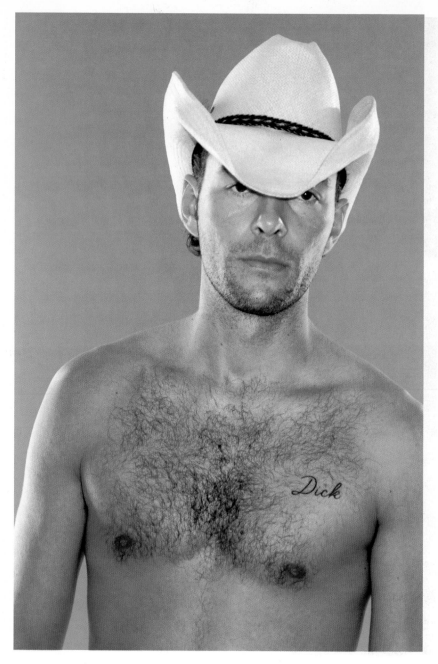

Jürgen Teller, Dick Page, 1996

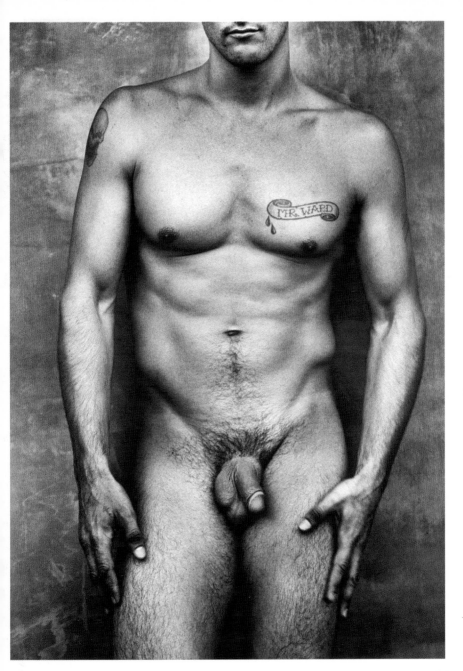

Andreas H. Bitesnich, Tony # 27, 1995

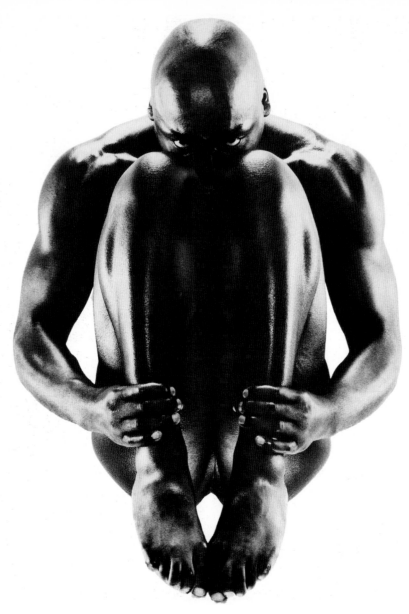

Andreas H. Bitesnich, Roy # 15, 1995

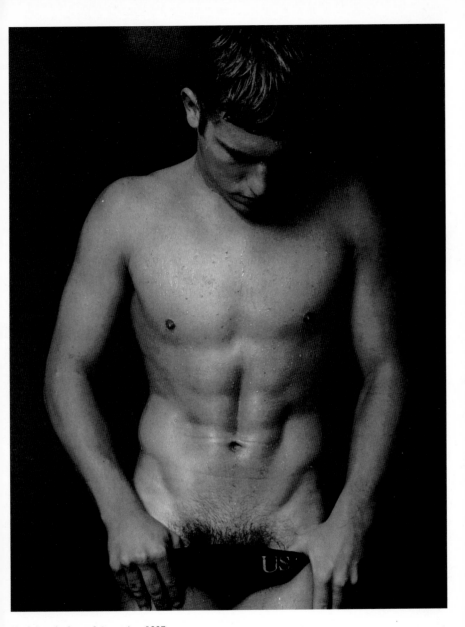

Mark Lynch, Grant Gritzmacher, 1997

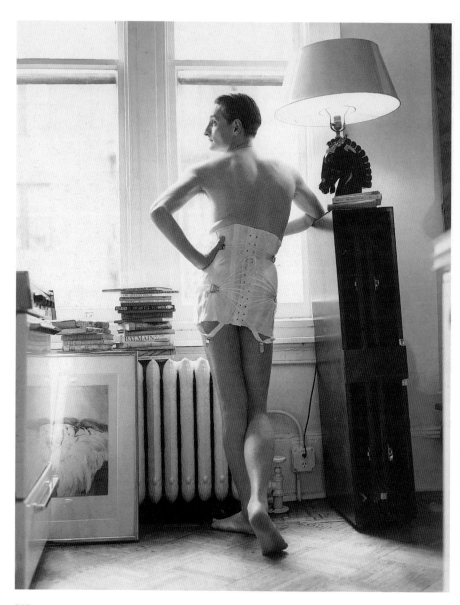

Steven Meisel, Hamish Bowles, 1993

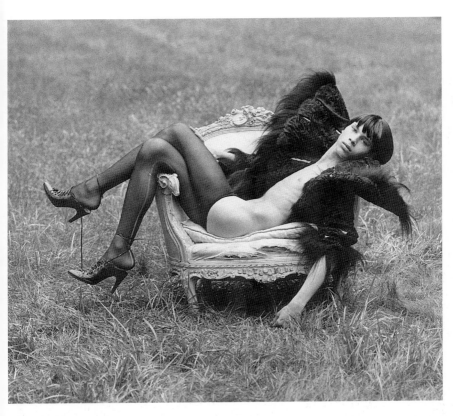

Steven Meisel, Sean, 1987

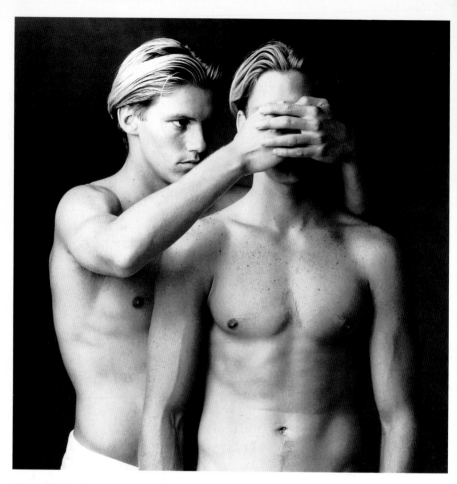

Blake Little, Derek and Keith, 1996

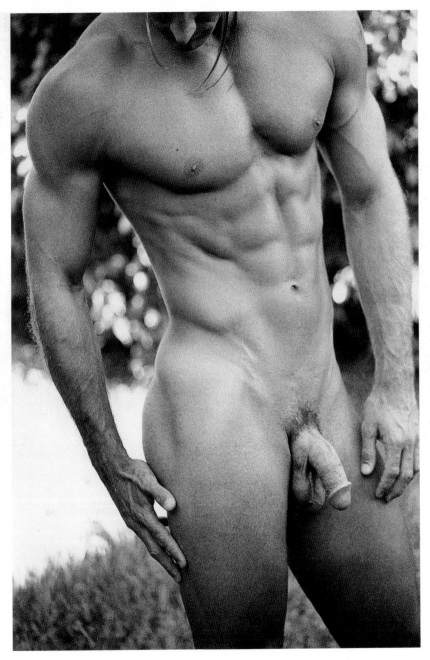

Andy Devine, 1996

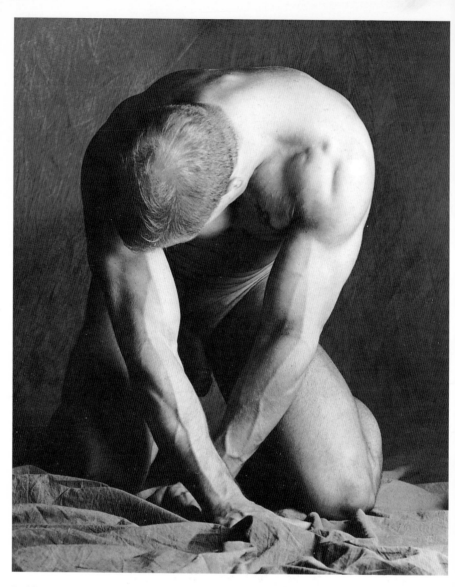

David Morgan, Nick, 1991

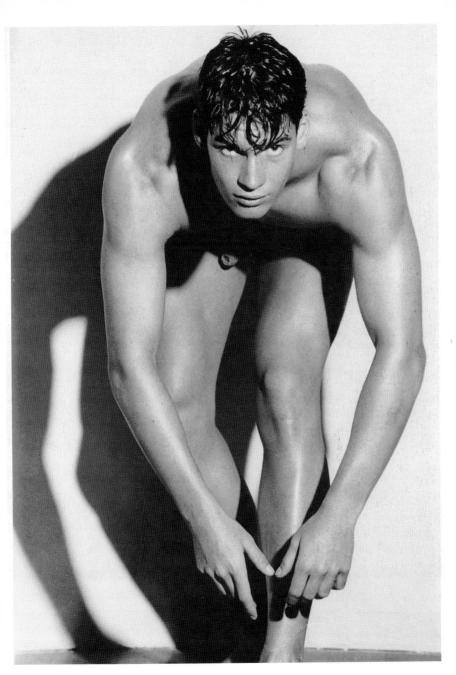

Herb Klein, Charlie, 1993

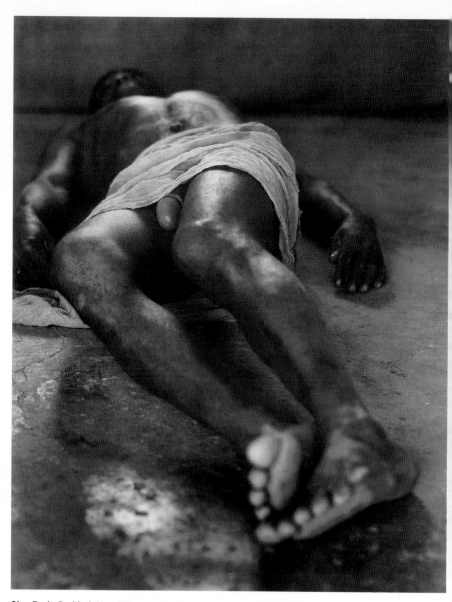

Gian Paolo Barbieri, Vezo Village at Sundown. A Fisherman Resting, 1994

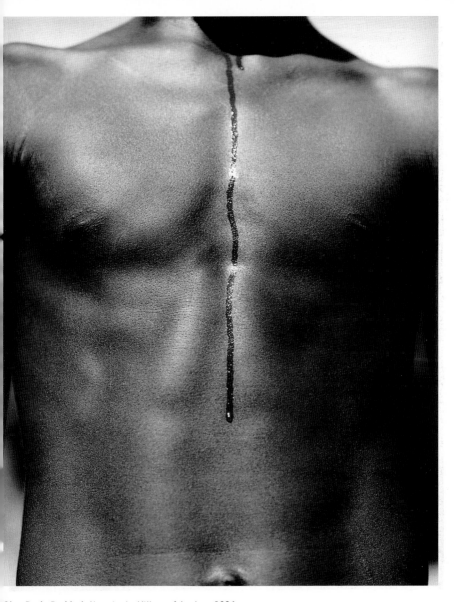

Gian Paolo Barbieri, Noon in the Village of Anakao, 1994

F.G

H.I.J

K.L

M.N

O.P

Q.R

Copyright . Bildnachweis . Crédits photographiques

"Buy them all and add some pleasure to your life."

Art Now
Eds. Burkhard Riemschneider,
Uta Grosenick

Art. The 15th Century
Rose-Marie and Rainer Hagen

Art. The 16th Century
Rose-Marie and Rainer Hagen

Atget's Paris
Ed. Hans Christian Adam

Best of Bizarre
Ed. Eric Kroll

Karl Blossfeldt
Ed. Hans Christian Adam

Chairs
Charlotte & Peter Fiell

Classic Rock Covers
Michael Ochs

Description of Egypt
Ed. Gilles Néret

Design of the 20th Century
Charlotte & Peter Fiell

Dessous
Lingerie as Erotic Weapon
Gilles Néret

Encyclopaedia Anatomica
Museo La Specola
Florence

Erotica 17th–18th Century
From Rembrandt to Fragonard
Gilles Néret

Erotica 19th Century
From Courbet to Gauguin
Gilles Néret

Erotica 20th Century, Vol. I
From Rodin to Picasso
Gilles Néret

Erotica 20th Century, Vol. II
From Dalí to Crumb
Gilles Néret

The Garden at Eichstätt
Basilius Besler

Indian Style
Ed. Angelika Taschen

London Style
Ed. Angelika Taschen

Male Nudes
David Leddick

Man Ray
Ed. Manfred Heiting

Native Americans
Edward S. Curtis
Ed. Hans Christian Adam

Paris-Hollywood.
Serge Jacques
Ed. Gilles Néret

20th Century Photography
Museum Ludwig Cologne

Pin-Ups
Ed. Burkhard Riemschneider

Giovanni Battista Piranesi
Luigi Ficacci

Redouté's Roses
Pierre-Joseph Redouté

Robots and Spaceships
Ed. Teruhisa Kitahara

Eric Stanton
Reunion in Ropes & Other Stories
Ed. Burkhard Riemschneider

Eric Stanton
The Sexorcist & Other Stories
Ed. Burkhard Riemschneider

Tattoos
Ed. Henk Schiffmacher

Edward Weston
Ed. Manfred Heiting

www.taschen.com